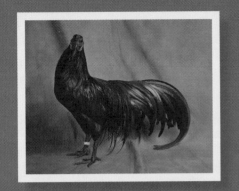
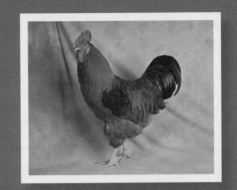
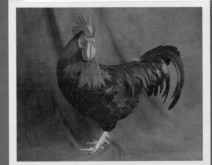

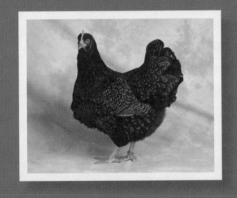
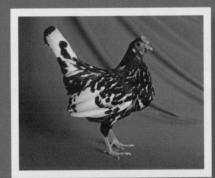
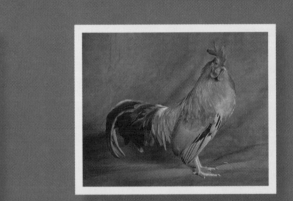
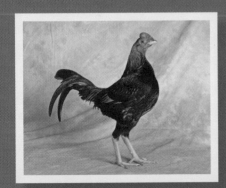
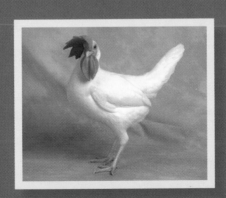
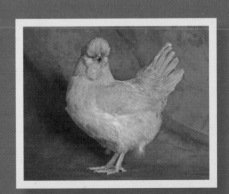

BEAUTIFUL CHICKENS

PORTRAITS

of

CHAMPION BREEDS

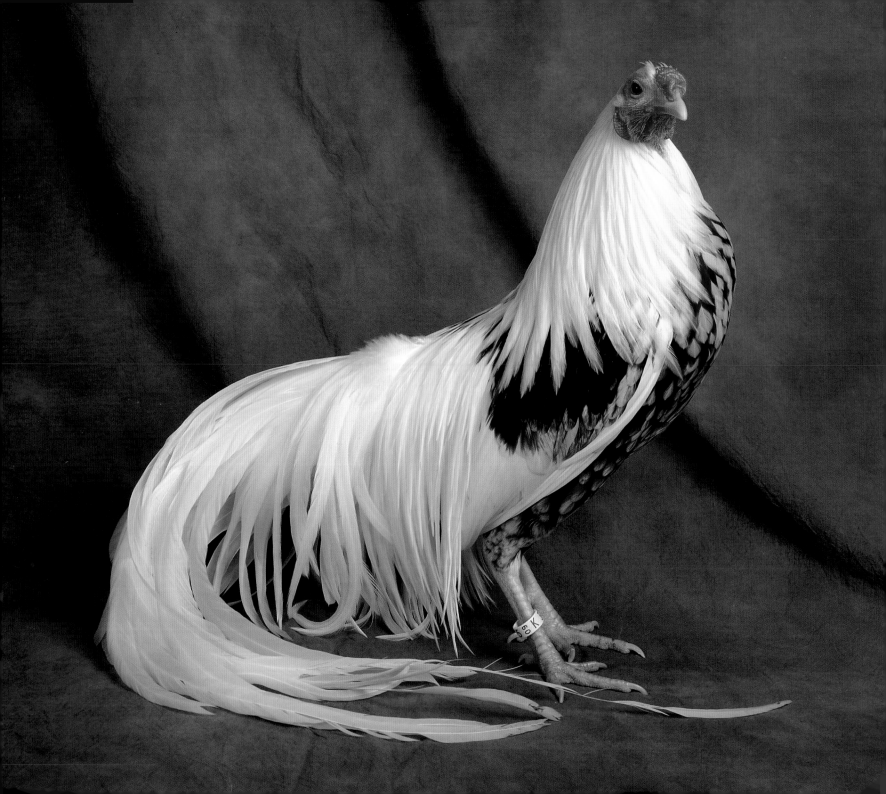

BEAUTIFUL CHICKENS

PORTRAITS

of

CHAMPION BREEDS

by CHRISTIE ASCHWANDEN
photographed by ANDREW PERRIS

MURDOCH BOOKS

Published in 2011 by Murdoch Books Pty Limited

Murdoch Books Australia
Pier 8/9, 23 Hickson Road
Millers Point NSW 2000
Phone: +61 (0)2 8220 2000
Fax: +61 (0)2 8220 2558

This book was conceived, designed and produced by

Ivy Press

210 High Street, Lewes, East Sussex BN7 2NS, UK

Creative Director Peter Bridgewater
Publisher Jason Hook
Art Director Wayne Blades
Senior Editor Polita Anderson
Designer Ginny Zeal
Photographer Andrew Perris
Photography Assistant Anna Stevens
Illustrator David Anstey

National Library of Australia Cataloguing-in-Publication entry
Author: Aschwanden, Christie.
Title: Beautiful chickens / Christie Aschwanden.
ISBN: 9781742666105 (pbk.).
Notes: Includes index.
Subjects: Chickens.
Dewey Number: 636.5

Printed in China
Colour origination by Ivy Press Reprographics

9 8 7 6 5 4 3 2 1

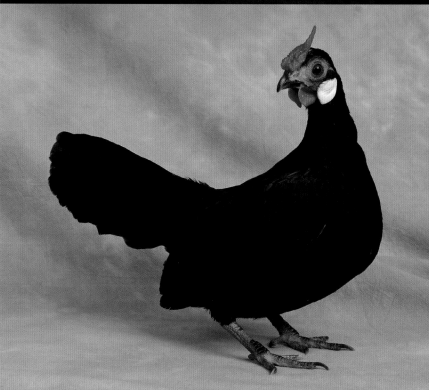

CONTENTS

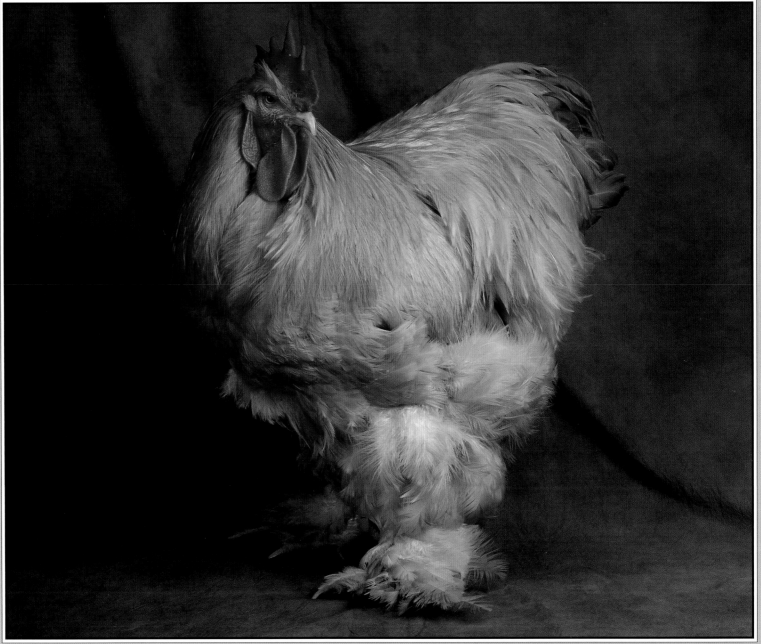

INTRODUCTION

WHILST THEIR POPULARITY AS PETS HAS WAXED and waned over past centuries, chickens have always won the hearts of fanciers. From the 'Cochin craze' of the 1880s that made fluffy-feathered Cochins a must-have item to the current resurgence in chicken keeping in urban neighbourhoods, the humble chicken has enjoyed repeated waves of popularity.

Keepers know that individual chickens have distinct personalities and, with regular handling and care, may develop a special bond with their human companions. Chickens can be trained to come when called, and with the right coaxing and training may learn to perform elaborate tricks in return for food or attention. Of course, they have innate motives like any other creature, and many a rooster has become aggressive toward a human it perceives as moving in on his lady friends. Likewise, broody hens will readily peck and scream at anyone who tries to disturb her nest or steal her eggs. Yet, for the most part, chicken behaviour tends towards endearing.

The beautiful plumage of ornamental breeds can provide a splash of colour and beauty to the back garden equal to that of the most sought-after songbirds. Chickens can exhibit a dazzling array of features, from the FRIZZLE's exotic feathers, to the APPENZELLER SPITZHAUBEN's distinctive headdress and the WELSUMMER's iconic plumage.

Each photograph in this book is accompanied by a page with information on the breed's history, qualities and appearance. Some of the chickens are ancient breeds such as the NANKIN; others are more recently developed such as the NEW HAMPSHIRE. Here you will learn about birds raised for meat such as the INDIAN GAME, and others kept mostly for eggs such as the LEGHORN. Also included are dual-purpose breeds such as the RHODE ISLAND RED and ornamental ones like the BELGIAN BARBU D'ANVERS.

This book is not an exhaustive catalogue – it is merely a sampling of some of the particularly attractive breeds. We hope you will enjoy the avian beauty our photographer has captured on these pages.

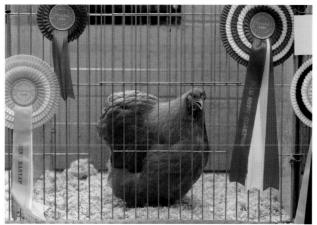
Above: With the popularity of poultry keeping as a hobby rapidly on the increase, there is a growing interest in showing birds at local exhibitions.

CHICKENS IN CIVILISATION

LIKE ALL BIRDS, CHICKENS EVOLVED FROM A GROUP of theropod dinosaurs, and their ancestors include the mighty *Tyrannosaurus rex*. The genus *Gallus*, to which the modern chicken belongs, emerged around eight or nine million years ago, and includes the red jungle fowl, considered to be the closest relative to today's chickens. In fact, it was Charles Darwin who first proposed a relationship between red jungle fowl and chickens after observing the two species interbreeding and producing fertile offspring.

Archaeological evidence suggests that chickens were first domesticated about eight thousand years ago in a region of Asia around modern-day Pakistan and India. They were most likely kept for game fighting rather than agricultural purposes, in Europe as well as Asia. Centuries later, it was noticed that chickens were an easy source of tasty meat and people began raising them for food. Every smallholding in Europe and America had a garden flock to provide nourishment for the family. Thus began a split in chicken breeding: some being raised for food, others for fighting.

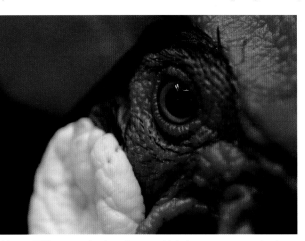

Above: Different poultry breeds vary widely in appearance, colouring and feather formation but all share basic elements of external anatomy.

After the British Parliament banned cockfighting in 1849, many fanciers began breeding game birds for their beauty and for exhibiting. The 1800s witnessed the 'Cochin craze', these fluffy fowl finding favour amongst farmers and high-society members alike. Subsequently, with the rise of industrial agriculture in the mid-20th century, fewer families kept chickens – the few that were kept in the suburbs were raised as pets or purely for exhibition. However, the emergence of a local foods movement in recent years has brought about a new surge in domestic poultry farming, and urban dwellers from London to Los Angeles have made chicken keeping trendy once again.

Scientific researchers have long used chickens to study biology. At the turn of the 20th century, University of Cambridge geneticist William Bateson used them to study patterns of inheritance. In 1966, Rockefeller University scientist Peyton Rous was awarded the Nobel Prize in Physiology or Medicine for his research on chickens that led to the discovery of the first known cancer-causing virus.

POULTRY STANDARDS

I N 1865, A PREDECESSOR TO THE BRITISH POULTRY Club published the world's first official list of poultry standards, *The Standard of Excellence in Exhibition Poultry.* The list spelt out the ideal features and qualities for specific poultry breeds and was meant as a guide for judges at poultry contests. The American Poultry Association soon developed its own list, the *Standard of Excellence,* published in February of 1874. Since their creation, the Standards have stood as the official record of poultry breeds in Britain and the USA. They outline the qualities and characteristics judges should use to rate individual fowl during poultry competitions, and also offer guidance to breeders striving to produce birds that exhibit their breed's hallmark features.

As the official record of poultry breeds, the Standards are designed to remain relatively stable, and changes are made only by consensus after careful consideration.

The modern *British Poultry Standards,* now in its sixth edition, contains over ninety chicken breeds, divided into two main classifications: hard feather and soft feather.

Hard feather refers to coarse, tight feathering, found mostly on game birds, whilst soft feather describes the fluffier feathers most commonly associated with chickens. From those two classifications, the breeds are further differentiated into Heavy, Light and True Bantam breeds. Heavy refers to large birds such as the WYANDOTTE, whilst light refers to smaller breeds like the LEGHORN. True Bantams are miniature breeds such as the SEBRIGHT, which have no full-sized equivalent.

Each chicken breed has a unique entry in the *British Poultry Standards* outlining its place of origin, classification and brief history. The Standard also lists the breed's general characteristics, broken down into categories – carriage, body type, head, neck, legs and feet, and plumage. Where these vary by gender, they are listed separately for each sex. Many breeds come in several colour types (e.g. barred or black), which the Standard describes and lists in a scale of points, also listing the optimal weights and serious defects that should not be present. Illustrations and photographs round off each entry.

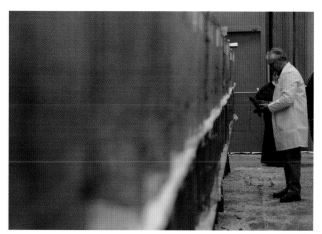

Above: Poultry judges follow and apply the Standard literally, carefully considering every specimen, according to the scale of points provided.

THE BREEDS

PEOPLE RAISE CHICKENS FOR THREE MAIN PURPOSES: eggs, meat and exhibition. Most breeds are suited to one of these, though so-called 'dual-purpose' breeds are well adapted to both egg and meat production. Such breeds find favour amongst back-garden keepers, who prize them for their practical value. RHODE ISLAND REDS, BARNEVELDERS, AUSTRALORPS, CROAD LANGSHANS, WYANDOTTES and ORPINGTONS are but a few that produce both excellent eggs and fine meat.

Some breeds were developed for their eggs rather than meat, and these hens tend to have large eggs and a reliable laying cycle that extends through most of the year. Whilst hens need a rooster's services to lay fertile eggs, the infertile eggs they produce without a male's help are perfectly tasty and nutritious. City dwellers often choose to keep only hens to spare neighbours the rooster's early wake-up call. Urban poultry farmers often select breeds such as the MARANS, which lay spectacular chocolate-coloured eggs, or the ARAUCANA, which lay striking green or blue eggs. Amongst commercial egg producers,

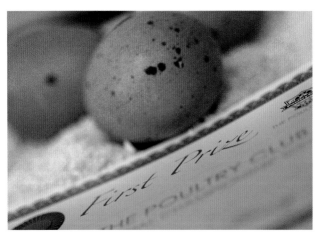

Above: Fanciers also exhibit produce at agricultural shows. Judges assess the shell's shape, colour and thickness and may even crack open the egg.

the LEGHORN remains king, because the breed tolerates confinement, matures early and produces upwards of two hundred and seventy eggs per year.

Those who raise chickens for meat look for different qualities altogether: a large breast, favourable feed-to-meat conversion ratio and an ample carcass. The INDIAN GAME is today's most numerous meat breed. It features a large, squat body, especially tender because the birds wait patiently for feeding time rather than build up muscles by running around foraging. Other meat breeds include PLYMOUTH ROCKS, ORPINGTONS and BRAHMAS.

Of course, many aficionados raise chickens as pets or for show. Most breeds have a club or group of fanciers dedicated to its refinement and perpetuation. Whilst all breeds may be entered into competitions, some breeds such as the DUTCH BANTUMS, BURMESE and SEBRIGHT BANTUMS are often raised specifically for exhibition. BOOTED BANTAMS, JAPANESE BANTAMS and YOKOHAMAS are also very popular exhibition breeds, raised for their beauty and the pure pleasure that comes from befriending such lovely creatures.

PREPARING FOR SHOWS

POULTRY EXHIBITIONS ARE LIKE BEAUTY PAGEANTS for chickens, allowing fanciers to flaunt their most exquisite fowl. Preparations for such events begin long before show day, often even before the eggs hatch. Some breeds attain their beauty peak before they are a year old. In such cases the handler strives to time the breeding and hatch so that the bird's exhibition qualities climax in synch with the show dates.

Fanciers pay close attention to their fowl's nutritional needs and carefully select feed components to maximise each breed's traits. Since corn and grass in the diet may enhance the yellowish tinge on a bird's legs, some owners feed extra corn to their birds, or withhold it, depending on whether yellow or white legs are required. An exhibition chicken needs just the right amount of calories and protein to ensure it develops properly, and does not become unduly lean or fat.

Potential show chickens are handled often so that they are accustomed to human touch. Many fanciers will also move them into their own cage prior to the event so that they become comfortable in this environment. At the show, the chicken will reside in a single cage and must remain unruffled when inspected by the judge.

About a week before the show, a bird's housing area is tidied and fresh litter put down to keep the feathers clean. Parasites such as mites must be kept under control, usually using a powder or spray. A few days before the exhibition comes the most important preparation of all: the chicken bath. Washing with a mild soap and warm water can vastly improve a chicken's appearance by removing unsightly dirt and dust. The fancier carefully lathers then rinses the bird, before wrapping it in a towel to remove excess water.

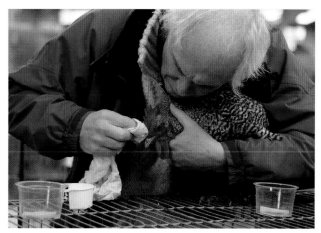

Above: Fanciers spend hours preparing their fowl for exhibition. Oil may be applied to the legs, earlobes, combs and wattles for a pleasant gleam.

The feathers are gently dried and fluffed under a heat lamp or blow dryer. If dirt remains in the scales of the legs, it may be removed with a cocktail stick and the legs then coated with mild oil to give them a pleasant sheen. Oil may also be applied to the comb, earlobes and wattles to make them more attractive and, in some breeds, the comb may be trimmed to conform to the breed's Standard.

KEEPING CHICKENS

CHICKENS NEED SIMPLE ACCOMMODATION AND little space compared to larger animals. They require a secure indoor shelter of at least 75 square centimetres (1 square foot) per animal (or 50 square centimetres/8 square inches for bantams). Cover the floor of the coop with a litter of fresh straw or wood chips. (Avoid hay, as it may contain harmful mould spores.) The inside of the coop should feature ample ventilation to prevent overheating and guard against moisture build-up on the litter.

Hens prefer to lay their eggs in a protected, private space. A cosy nest box slightly larger than the hen is ideal and also provides a convenient place to collect eggs. Scatter some straw or wood chippings inside the nest box to prevent egg breakage and to make it more comfortable. The box should have walls on three sides and, if possible, a door or curtain on the front to give the hen privacy whilst she lays. Provide at least one nest box for every four hens. Often the hens will favour one over the others, their preference often suddenly and inexplicably changing.

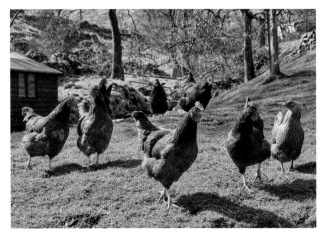

Above: The outdoor area needs to be large enough to allow chickens to roam on good pasture every day while other areas recover.

Coops should contain ample perches for chickens to roost at night. They should stand off the ground, higher than the nest boxes but within easy reach for the chickens, and should be rounded and broad enough for the fowl to roost comfortably. There should be at least one window to let in sunshine as light exposure increases a hen's egg output. Egg production peaks at about fourteen hours of daylight, so in autumn and winter some keepers opt to supplement natural with artificial light to increase the yield.

Chickens best thrive when given access to outdoor runs in addition to indoor space. The outdoor area should offer access to grass or other greens whilst providing robust protection against predators such as foxes, hawks and domestic dogs. In recent years so-called 'chicken tractors' have enjoyed a surge in popularity. These portable coops sit securely on the ground and give access to pasture whilst keeping chickens safe from predators. Suitable even for a back garden, they can be moved often to allow the chickens to graze and fertilise the whole area.

CARING FOR CHICKENS

NOTHING CAN MATCH THE WONDER THAT COMES from watching a fuzzy, peeping chick emerge from an egg. Once it does, its needs are simple: warmth, water and, within a day or two, food. A broody mother will see to all of her offspring's needs, but most breeders today use mechanical incubators to hatch the eggs. These keep the eggs at a constant temperature and humidity, and turn them at regular intervals to mimic a brooding hen's natural jostling. When starting out many fanciers begin by ordering day-old chicks from a hatchery. These are usually sent through express mail and must be shipped in groups of about two dozen or more to give them sufficient body heat to keep them warm on the journey.

Once they arrive at their final home, day-old chicks are kept warm under a heat lamp, usually placed in a bin or enclosed area to guard against draughts and prevent them from wandering into trouble. The lamp should be placed so that the temperature underneath stays at about 39° C (102° F). When the temperature is right, the chicks will be distributed around the edges of the light, not huddled directly underneath it (as they do if it is too cold) or scattered far away (if the heat is too great).

All chickens need access to clean water, and youngsters must be given this in troughs too shallow for them to drown. Chicks require free access to high-protein (20 to 22 per cent) feed in a bin with enough access holes to allow most of them to eat at once, to prevent bullying. This chick feed is usually small pellets or meal. As birds mature, feed can be reduced to about 16 per cent protein, the type given to laying hens. Exact caloric needs vary by breed, but larger varieties generally eat around 4–6 oz (110–170 g) of standard feed per day, whilst bantams eat around 2–3 oz (50–85 g). Chickens will eat any kitchen scraps, especially greens, vegetable matter and breadcrumbs. Chickens of all ages need access to grit, which is required by the gizzard to grind hard grains. As pullets reach laying age, they will require access to calcium-rich oyster shells or limestone grit to provide them with enough minerals to produce hard egg shells.

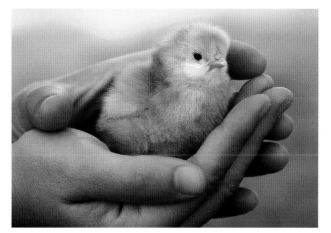

Above: Baby chicks can scamper about immediately upon hatching. The key considerations are to keep them warm, dry, fed and watered.

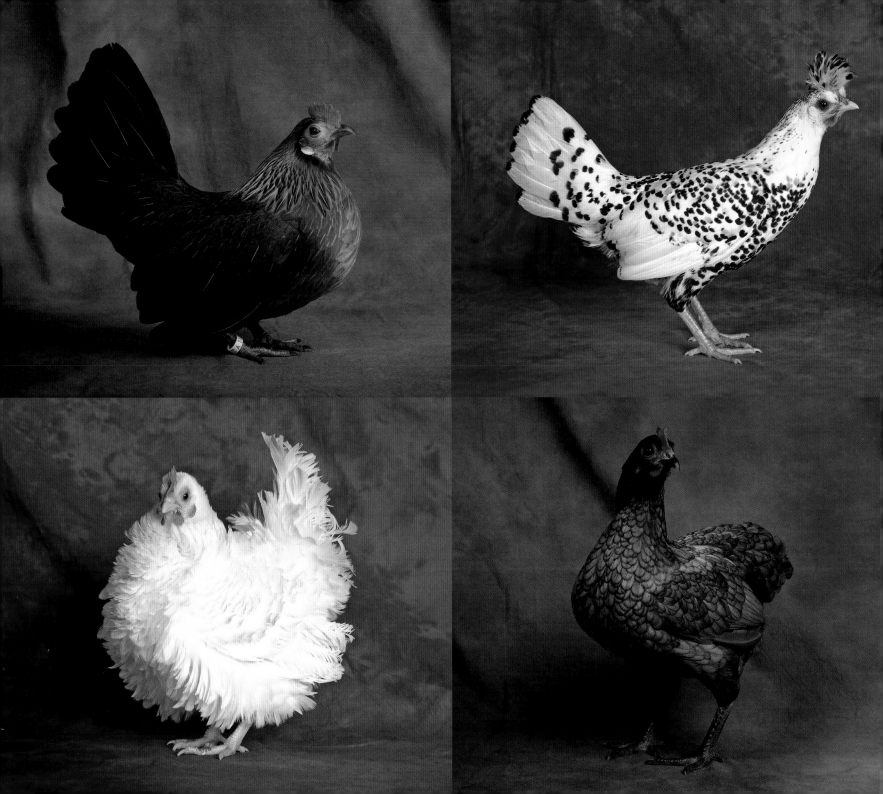

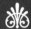

THE CHICKENS

Love to COUNT YOUR CHICKENS? Here are over 40 FABULOUS *specimens* to delight the most discerning fowl-fancier. Whether you like them *rangy and elegant* or *round and comfortable*, there'll be a model to match every taste. We bring you ...

BEAUTIFUL CHICKENS!

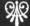

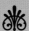

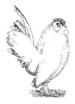

BELGIAN BARBU D'ANVERS

COCK

The BELGIAN BARBU D'ANVERS is an old-fashioned bantam breed that has no standard equivalent. Also called the Antwerp Belgian, it has been around for more than three hundred years. It experienced a huge surge in popularity in the early 1900s when it was imported to the USA, although it was only admitted into the American Poultry Association's *Standards of Perfection* in 1949.

Features

The Belgian Barbu D'Anvers is distinguished by its rose comb and featherless legs. It stands upright with a proud posture, head held high. Its medium-sized wings slope downwards and it has large sickles that appear sword-like. The breed has a large head, short beak and big, prominent dark eyes. A feathery beard features prominently on the face, covering ears and ear lobes. Its beard and eyebrow puffs give it a muffed appearance.

Use

Purely an ornamental breed, the Belgian Barbu D'Anvers is raised mostly for exhibition purposes. Cocks may become aggressive in certain circumstances, but hens tend towards friendliness. They prefer free ranging to confinement.

Related Breeds

The Belgian Barbu D'Anvers is one of several Belgian bantam breeds. The others are Barbu D'Uccle, Barbu de Watermael, Barbu d'Everberg, Barbu de Bitsfort and Booted Bantam.

Size

Bantam hen weight 570–680 g (20–24 oz)

Bantam cock weight 680–790 g (24–28 oz)

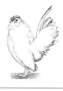

Origin & Distribution

As its moniker suggests, the Belgian Barbu D'Anvers originated in Belgium – the name translates to 'Bearded from Antwerp'. The breed was first brought to England in the early 1900s and its popularity quickly grew. Today it is kept by aficionados across Europe and the USA.

Belgium

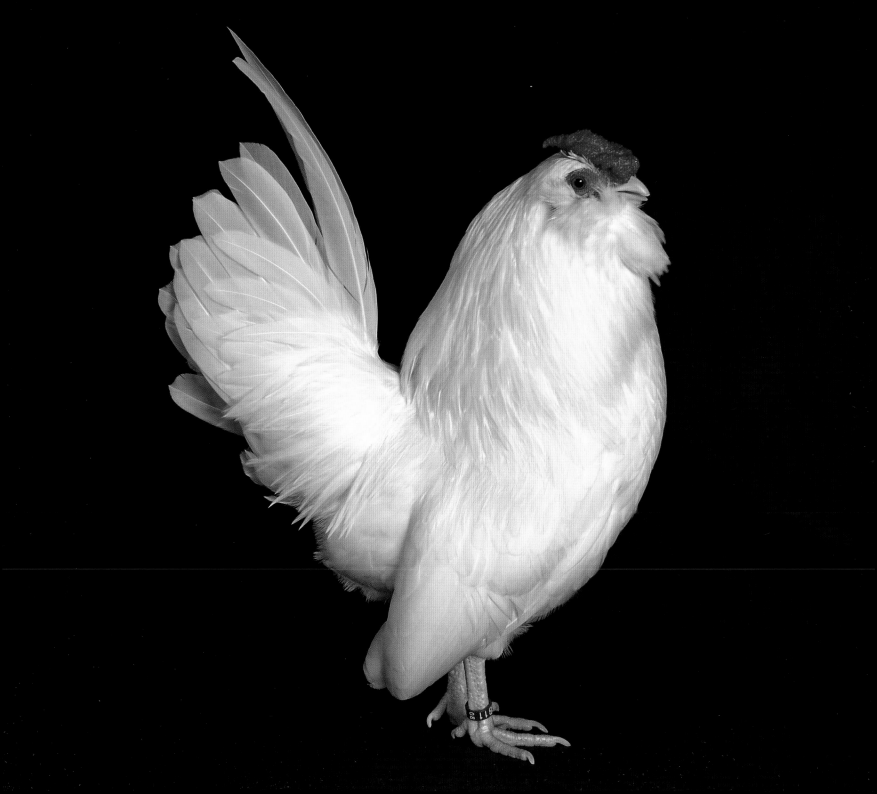

ORPINGTON

H E N

Named after the Kent village where its original breeder, William Cook, farmed, the ORPINGTON was first introduced in 1886. Originally bred for utility as a dual-purpose bird, its looks soon caught the attention of exhibitioners, who began selectively breeding it to accentuate its flamboyant feathers and pleasing shape. The hen pictured here exhibits the black plumage type.

Features

The Orpington has a distinctive round shape. Its neck is so short that its head may appear to rise up out of the globe of its body. It has a single five-point comb with red wattles and ear lobes and a tail that sprouts up in a fluffy fountain of feathers. Its black feathers take on a lush green sheen in the sun and the plumage obscures most of its featherless legs, except the feet and ankles.

Use

Orpingtons are heavy breeders and quick to mature. They tolerate cold temperatures well and produce a steady number of eggs all year round, making them popular dual-purpose birds. The breed is renowned for its friendly demeanour and is relatively easy to train, making it a popular show breed.

Related Breeds

A hardy, strong breed, Orpingtons were created through careful breeding of a variety of birds, including Plymouth Rocks, Minorcas and Langshans.

Size

Hen weight 3.6 kg (8 lb)

Cock weight 4.6 kg (10 lb)

Origin & Distribution

The Orpington originated in England during the late 1800s. Though it arose in Europe, it reached the USA by the early 1900s and has become popular in North America as well as in England.

England

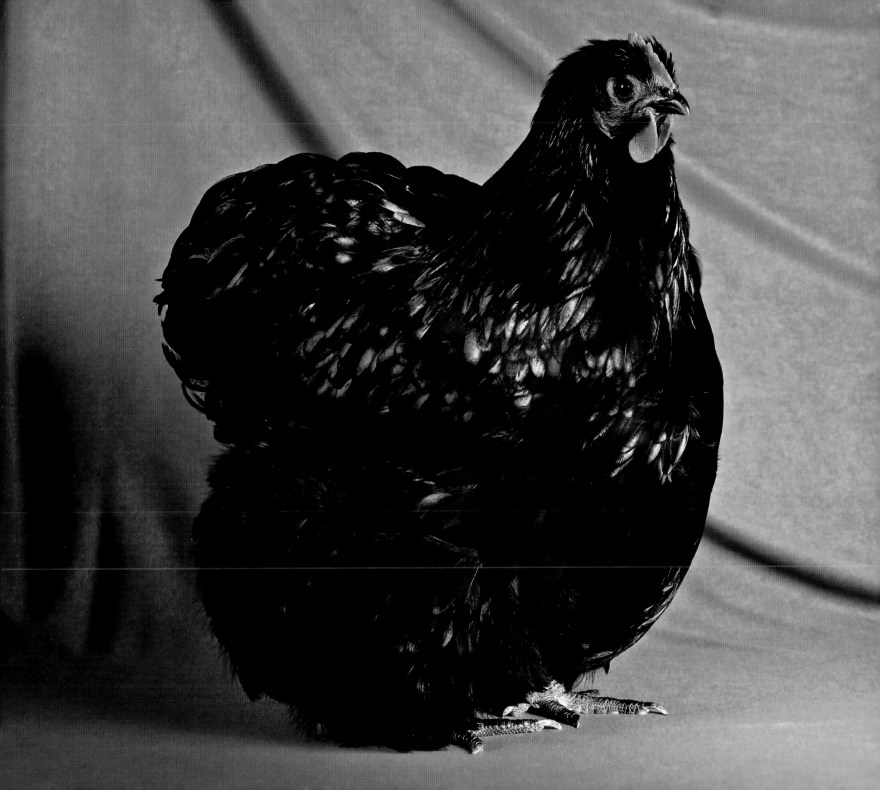

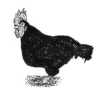

RHODE ISLAND RED

COCK

Like many breeds, the RHODE ISLAND RED takes its name from its place of origin. In 1954, the Rhode Island state legislature named the Rhode Island Red the state bird, making it one of only two domesticated birds ever to receive such a distinction. Ranked as 'recovering' by the American Livestock Breeds Conservancy, the Rhode Island Red is listed in Slow Food USA's *Ark of Taste*, a catalogue of foods in danger of extinction.

Features

Despite its name, the Rhode Island Red's plumage is actually more of a muddy maroon colour. The breed can sport either a single or rose comb and has medium-sized ear lobes and wattles. Often described as 'brick-shaped', Rhode Island Reds have a rather stout build with a short tail and yellow legs. They possess a serene demeanour and are a popular garden chicken.

Use

The Rhode Island Red is a dual-purpose breed prized for its steady output of brown to light-brown eggs. Hens can lay as many as 220 eggs per year. Rhode Island Reds are also fast growers and suitable for meat production.

Related Breeds

The Rhode Island Red shares its heritage with a medley of breeds that includes Red Java, Malay, Cochin, Brahma and Leghorn.

Size

Hen weight 2.9 kg (6½ lb)

Cock weight 3.9 kg (8½ lb)

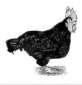

Origin & Distribution

This breed originated in Rhode Island, a tiny state in the north-east USA. The breed made its show debut in 1880 in nearby Massachusetts, and the British Rhode Island Red Club formed about 30 years later. Today the breed is popular throughout Europe and North America.

Rhode Island, USA

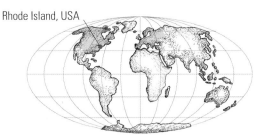

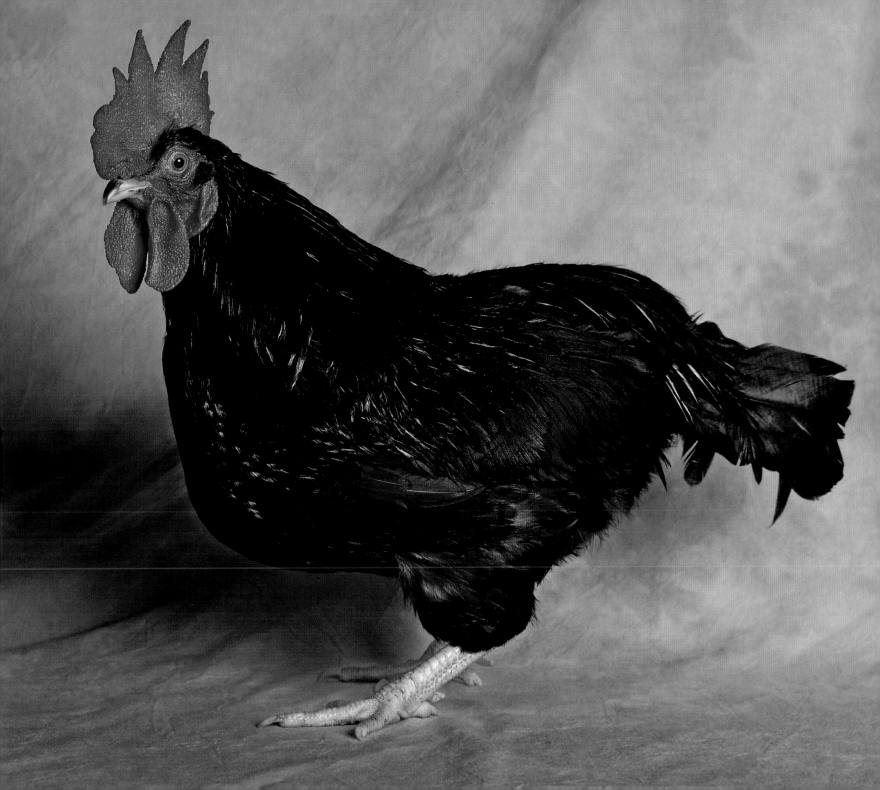

GERMAN LANGSHAN

HEN

Classified as a large fowl, soft feather breed, the GERMAN LANGSHAN is one of two related Langshan breeds recognised in the *British Poultry Standards*. The German Langshan is an elegant bird, with a round body and attractive plumage. Owing to its unusual height and upright posture, this fowl's shape resembles a wine glass when viewed in profile.

Features

The German Langshan carries itself with a towering elegance. Its breast is rotund and full and its short back forms a V shape, with the tail being rounded and short. Though the German Langshan's head, single comb and wattles are inconspicuous, the eyes are large and attentive. The breed has featherless shanks, making its legs appear especially long and lanky. It comes in three plumage colours – black, white and the blue (shown here).

Use

Raised both for show and for utilitarian purposes, the German Langshan is a strong, large bird that makes good meat. Hens lay brown or brown-yellow eggs. The breed does not fly well, so is easily confined, and it is not particularly aggressive.

Related Breeds

The German Langshan is closely related to the Croad Langshan and probably also owes some of its features to the Cochin, Plymouth Rock and Minorca.

Size

Hen weight 2.5–3.5 kg (5½–7¾ lb)

Cock weight 3–4.5 kg (6½–10 lb)

Origin & Distribution

The German Langshan was derived from the Croad Langshans imported from China to Germany and Austria by Major A. C. Croad in the late 1800s. This breed is found in Europe and North America.

Germany

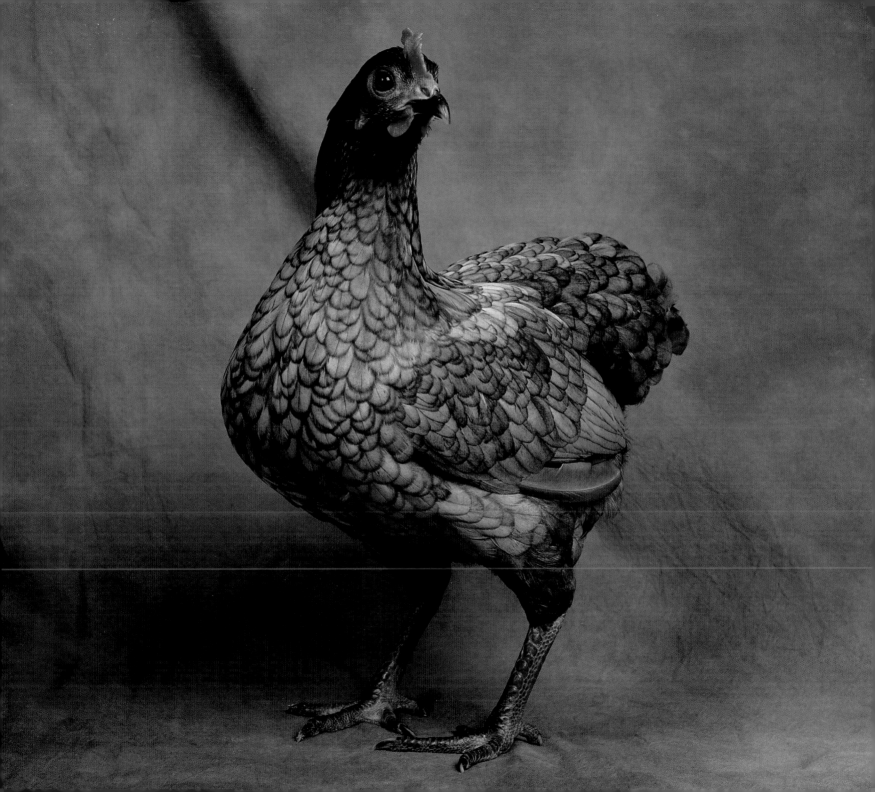

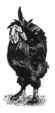

CROAD LANGSHAN

COCK

The Croad Langshan is a robust, full-feathered breed. It is one of two related Langshans developed from chickens imported to Europe from Asia in the late 1800s. This is a lively, intelligent fowl that is easily tamed. It likes to graze, although also tolerates confinement. The breed is calm, friendly and easy to handle, which makes it popular amongst hobbyists.

Features

This breed carries itself with an upright grace. It has a broad, arched breast, long breast bone and strong body. Its wings are held high, tucked upwards, and it has plentiful, elegant side hanger feathers, complemented by a tall tail consisting of a graceful plume of feathers fanning outwards in a cascade. Unlike the related German Langshan, the Croad Langshan has a feathered outer toe.

Use

Considered a dual-purpose breed, the Croad Langshan is raised both for eggs and meat. Hens lay brown or pinkish eggs, and trials showing that they lay reliably, even in winter, have gained the Croad Langshan a following as a laying breed.

Related Breeds

The Croad Langshan shares its heritage with a medley of breeds, including the Cochin, the German Langshan, the Australian Langshan and the Modern Langshan.

Size

Hen weight 3.2 kg (7 lb)

Cock weight 4.1 kg (9 lb)

Origin & Distribution

The Croad Langshan takes its name from Major A. C. Croad, who first imported Langshans to Britain from China's Langshan district, north of the Yangtze Kiang River. Today it's found throughout Europe, North America and Australia.

England

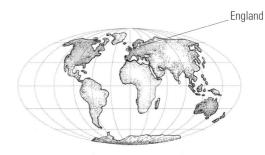

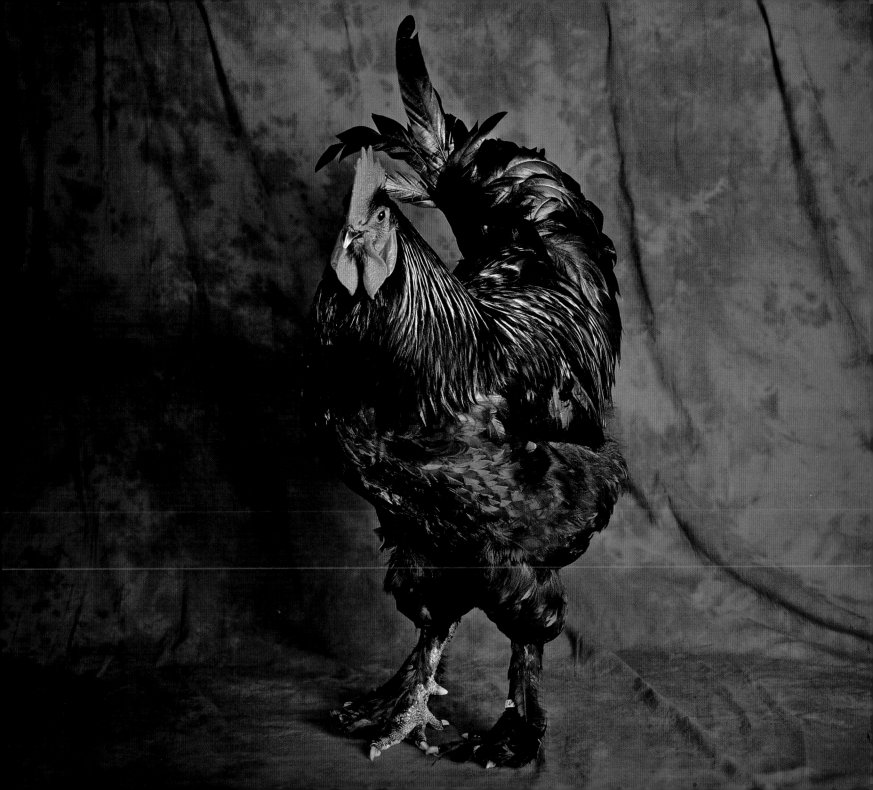

DUTCH BANTAM

HEN

Unlike many other bantam breeds, the DUTCH BANTAM has no standard-sized equivalent. They are also one of the tiniest and oldest bantam breeds, having originated in the 17th century. The breed's ancestors arose from Indonesia's jungle fowl and are thought to have been amongst the world's first domesticated chickens. Dutch Bantams are lively, beautiful birds that never fail to turn heads at exhibitions.

Features

The Dutch Bantam has an upright posture and carries itself in a dapper, lively manner. Its head is small and topped with a single red comb. It has a short back and a showy, upright tail. Its striking white ear lobes stand apart from its red wattles. The breed has 13 standard colours, and the hen (shown here) displays the gold partridge-colour type.

Use

The Dutch Bantam's flamboyant, eye-catching looks make these birds popular amongst exhibitioners and hobbyists. Their miniature eggs and diminutive bodies make them ill-suited for production purposes and they are not particularly cold hardy.

Related Breeds

The Dutch Bantam was developed from Indonesian jungle fowl. This breed may also share some of its heritage with the Old English and Rosecomb breeds.

Size

Bantam hen weight 400–450 g (14–16 oz)

Bantam cock weight 500–550 g (18–20 oz)

Origin & Distribution

The Dutch Bantam originated in Holland, from stock most likely imported by sailors coming from the Dutch East Indies. It was imported to the USA at least twice, and did not make its way to England until the late 1960s, but today it is a popular exhibition breed throughout North America, Europe and South Africa.

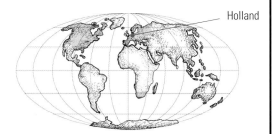

Holland

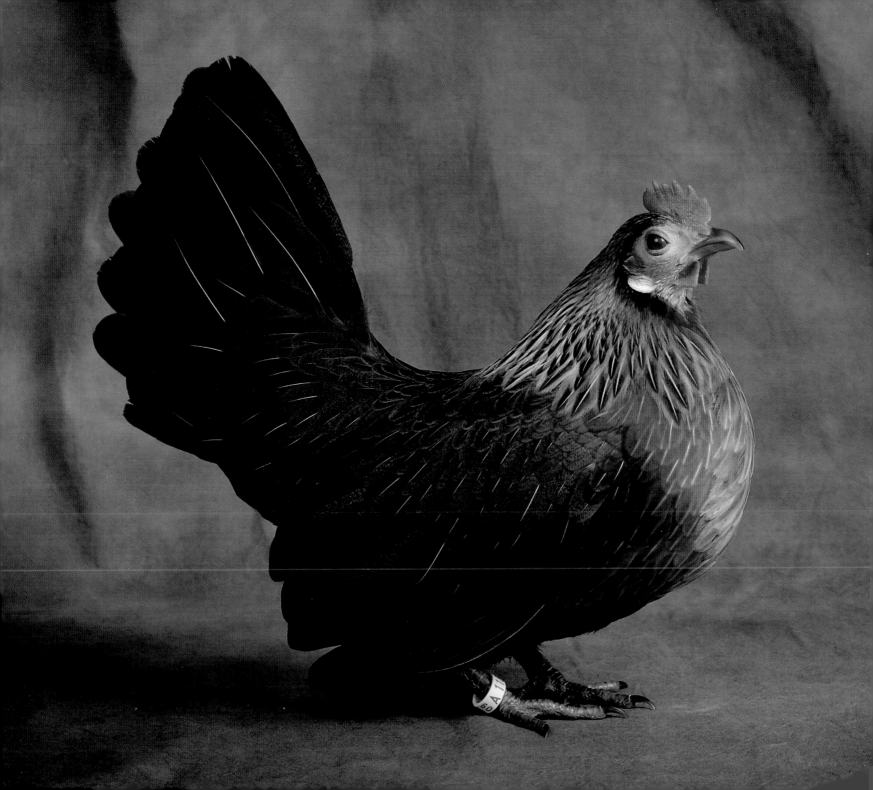

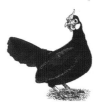

ROSECOMB BANTAM

HEN

Like the Dutch Bantam, the ROSECOMB BANTAM is a true bantam with no standard-sized equivalent. The breed suffers from low rates of fertility and hatching, a trait that may be linked to the genetic factors that give it its rose comb, since the occasional Rosecomb offspring born with a single comb seem to reproduce more easily.

Features

Without a doubt, the Rosecomb Bantam's signature feature is its pointy rose comb, which is found on both cocks and hens, though the male's comb is larger and more ornate than that of the female. The breed's pure white ear lobes stand out against its dark plumage and red wattles and comb. The Rosecomb Bantam's body is broad and short, and its forward chest is rounded and full. The long, upright tail extends out from the body in a gush of feathers. The black variety (shown here) has stunning black plumage with a magnificent greenish sheen.

Use

The Rosecomb Bantam is all show, valued for its ornamental headwear and luxurious plumage. The breed are poor layers and can be difficult to raise, owing to their low hatch and fertility rates. They are able fliers, but tolerate confinement.

Related Breeds

Given the Rosecomb Bantam's murky heritage, its modern relatives remain unknown.

Size

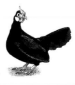

Bantam hen weight 450–510 g (16–18 oz)

Bantam cock weight 570–620 g (20–22 oz)

Origin & Distribution

Although considered an old breed of ancient origins, the Rosecomb Bantam's heritage remains a bit of a mystery. Most sources credit British breeders for its development and records show that Rosecomb Bantams were raised in England as early as 1493, when King Richard III began keeping them.

England

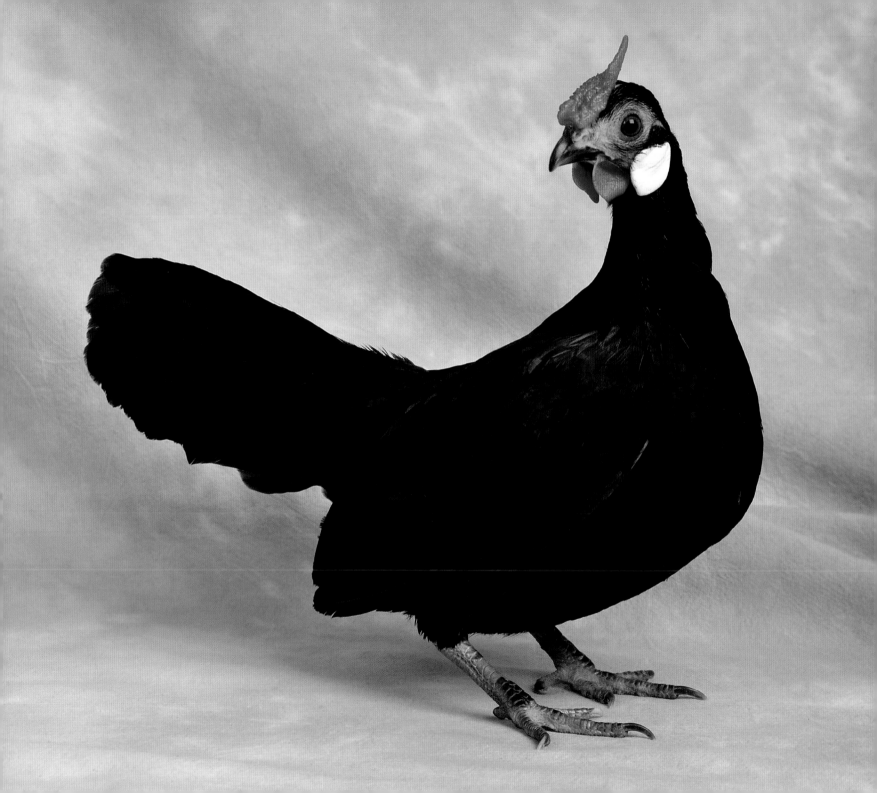

YOKOHAMA

COCK

The Yokohama is one of several long-tailed breeds that arose from fowl imported into Japan from China as early as AD 600. It takes its name from the Japanese port from which a number of long-tailed fowl were shipped to Europe in the late 1800s. These are petite, good-natured birds that carry themselves with a style and elegance reminiscent of a pheasant.

Features

Small and sleek, the Yokohama is prized for its lengthy, delicate tail, which can grow to extreme lengths. The bird has a long body and round breast and ridiculously abundant saddle hackles. The Yokohama can exhibit one of three different comb types: walnut, pea or single. Its comb, wattles and ear lobes are extremely small and undeveloped compared to its showy tail.

Use

Purely ornamental, Yokohamas are raised by enthusiasts who often go to great lengths to manicure the rooster's fancy tails. In exhibitions judges look for maximum tail length and give high marks to flowing tails with elegant side hangers. The ideal tail forms a graceful curve extending like a bridal train far behind it.

Related Breeds

The Yokohama is an Asian breed related to the Shokoku, Shamo and Phoenix.

Size

Hen weight 1.1–1.8 kg (2½–4 lb)

Cock weight 1.8–2.7 kg (4–6 lb)

Origin & Distribution

European breeders imported Yokohamas to Germany in the late 19th century and eventually the birds drew fanciers throughout Europe. In 1904 the British formed a Yokohama club and revised the name to include several long-tailed types. Today the Yokohama is raised throughout Asia, Europe and North America.

Germany

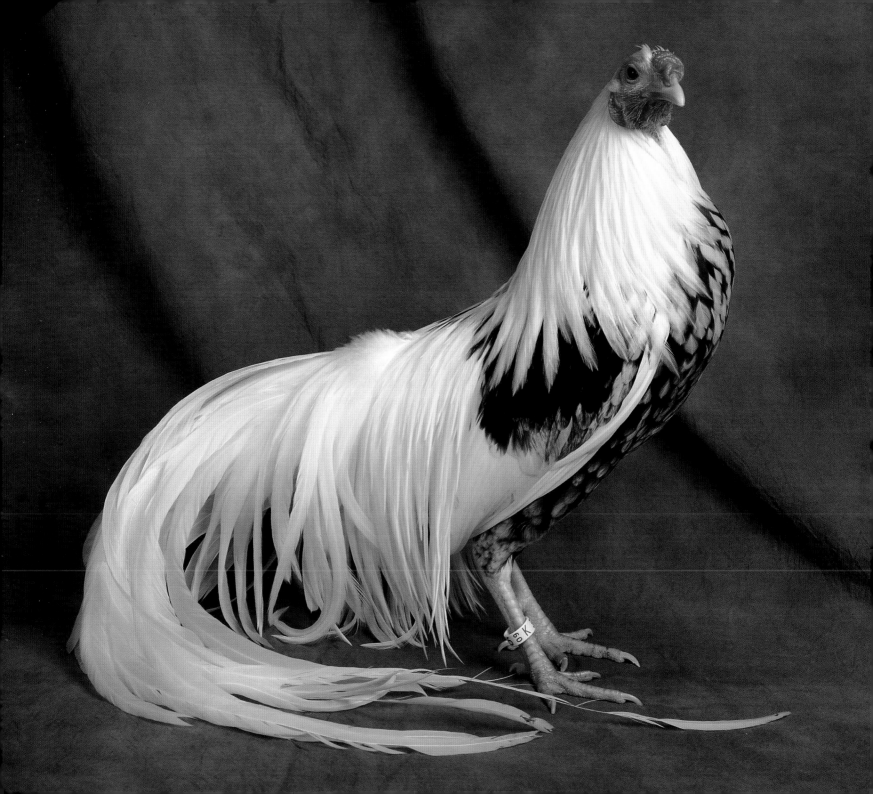

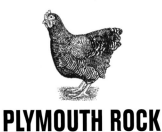

PLYMOUTH ROCK

HEN

The PLYMOUTH ROCK is a robust, practical fowl long favoured by smallholders in their native USA. The rise of large-scale commercial poultry production in the mid-20th century led to a drop in numbers, as more commercially viable breeds took over, but the recent resurgence in local foods has boosted the breed's popularity. Active and intelligent, they are considered a heavy, soft-feathered breed.

Features

The Plymouth Rock was first selected for the barred feather type shown here. The breed has an upright, five-point comb and medium-sized red wattles and ear lobes. The body is symmetrical and well balanced, with a broad back and breast. The head is carried upright and the tail is not overly long or ornate.

Use

Plymouth Rocks are reliable layers of tinted eggs, but also provide ample meat. They are cold hardy, easily tamed and their docile temperament makes them good choices for hobbyists. They are a popular choice amongst domestic enthusiasts, as they are not enthusiastic fliers, but readily confined with moderate fencing.

Related Breeds

An American breed, the Plymouth Rock is related to the Dominique, Cochin and Java.

Size

Hen weight 2.9 kg (6½ lb)

Cock weight 3.4 kg (7½ lb)

Origin & Distribution

The Plymouth Rock was developed in Worcester, Massachusetts, in the mid-1800s, and the first recorded exhibition of the barred Plymouth Rock took place in the USA in 1869. The breed reached England by 1871 and is still found in both the USA and UK.

Massachusetts, USA

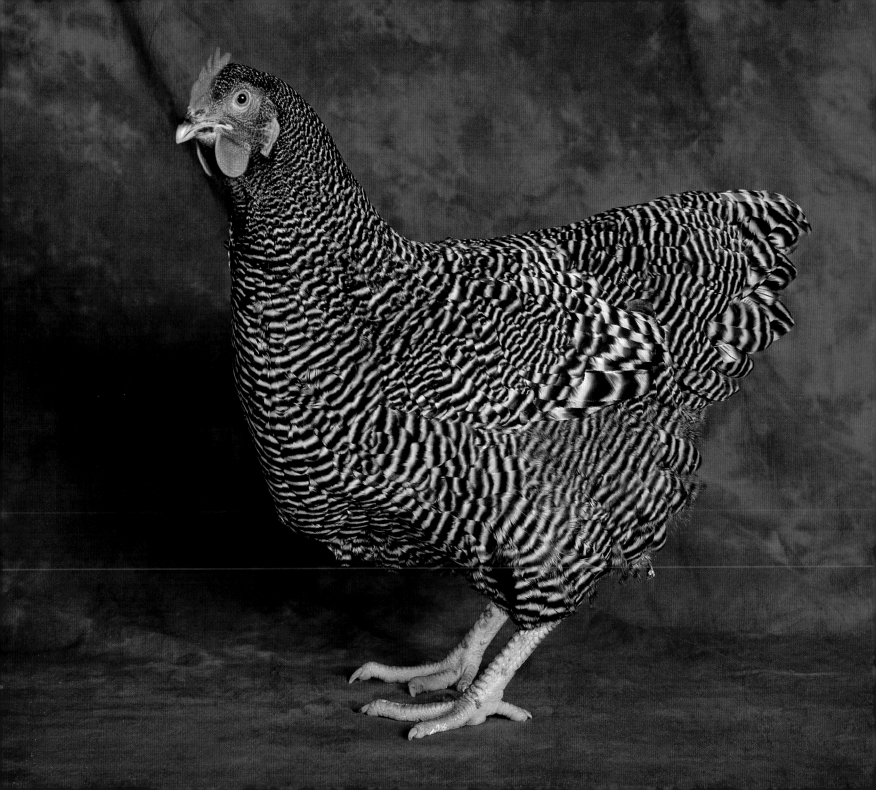

SUMATRA

COCK

A stately, elegant fowl, the SUMATRA is classified as a light-feathered, rare breed. Legendary for their flying ability, these chickens are rumoured to have once flown more than eight kilometres between the Indonesian islands of Sumatra and Java. Despite their prim appearance, Sumatras' behaviour can border on feral, as they jump about and readily fly, preferring to roost outside rather than in confinement.

Features

The Sumatra's posture is upright and dignified. Its body is muscular with a broad breast and an elongated back that extends flat to its very long tail. The black head is small with a miniature pea comb, tiny ear lobes and wattles so diminutive they are nearly indiscernible. Sumatras' lustrous plumage may be a luxurious black with beetle-green tones (shown here), blue or white.

Use

Once used for cockfighting, Sumatras now are kept mostly for show. They are slow to mature and have more feathers than meat, making them poor roasters. Hens begin laying their white eggs rather late, but they are able brooders and attentive mothers.

Related Breeds

The Sumatra's ancestors remain a bit of a mystery. Descended from Asian stock, they most likely emerged from a now-extinct type of wild Indonesian fowl.

Size

Hen weight 1.8–2.3 kg (4–5 lb)

Cock weight 2.3–2.7 kg (5–6 lb)

Origin & Distribution

The breed originated on the Indonesian island of Sumatra, from where it was imported to the USA, and later to Europe. The American Poultry Association admitted the breed in 1883, and the British Poultry Club followed suit in 1906. The breed is now kept by fanciers throughout the world.

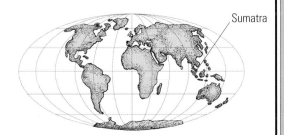

Sumatra

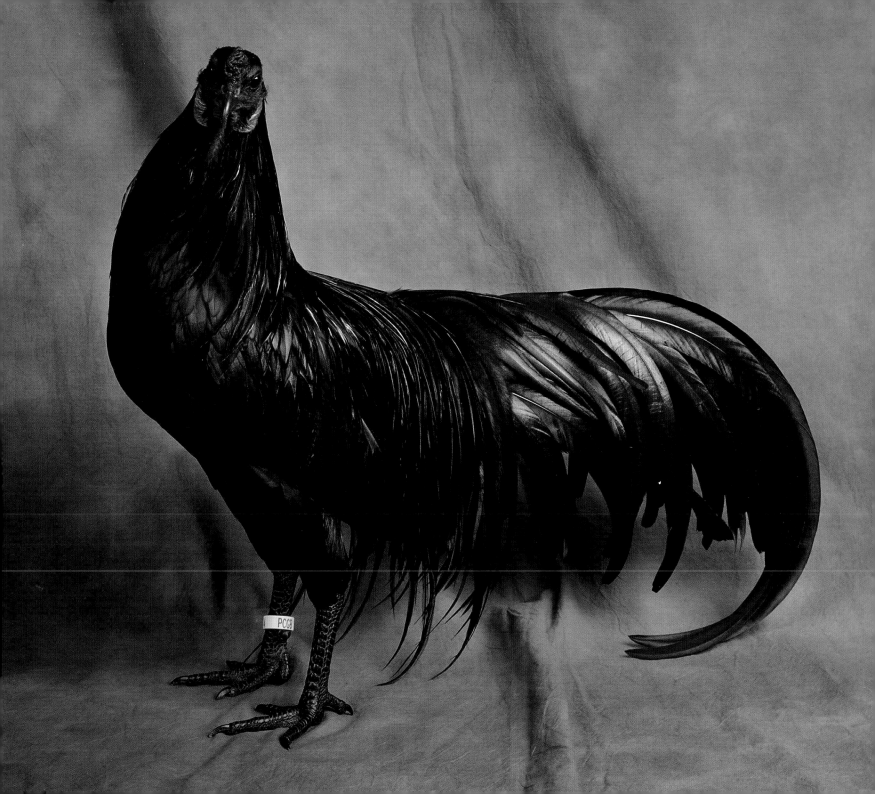

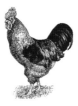

NEW HAMPSHIRE RED

COCK

Most new chicken varieties incorporate traits from several breeds, but the NEW HAMPSHIRE RED was developed solely by breeding Rhode Island Reds in an attempt to maximise the finer qualities of this original stock. As their names suggest, both breeds have a red hue. The New Hampshire's plumage exhibits several shades of red, making it easy to distinguish it from the Rhode Island Red.

Features

The New Hampshire Red has a long neck, a curved, stout body and a broad back that sweeps in a concave arc to the tail, which is upright and not overly showy. The head is medium-sized with a single, straight, upright comb. The red wattles and ear lobes are moderately sized and the face is smooth.

Use

Though attractive enough to please ornamental enthusiasts, the New Hampshire Red was bred for utility. They make fine meat birds, as they mature quickly and readily put on weight. But they are also prized for their large brown eggs, which the hens produce like clockwork.

Related Breeds

The New Hampshire Red was developed entirely through selective breeding of Rhode Island Reds without any contributions from other breeds.

Size

Hen weight 2.9 kg (6½ lb)

Cock weight 3.8 kg (8½ lb)

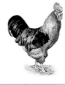

Origin & Distribution

Bred initially in New Hampshire, it took decades for this state's eponymous breed to gain acceptance. By 1935, it was deemed worthy of inclusion in the American Poultry Association's *Standards of Perfection*. By then the breed's popularity had reached Europe and it is now listed in the *British Poultry Standards*.

New Hampshire, USA

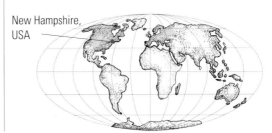

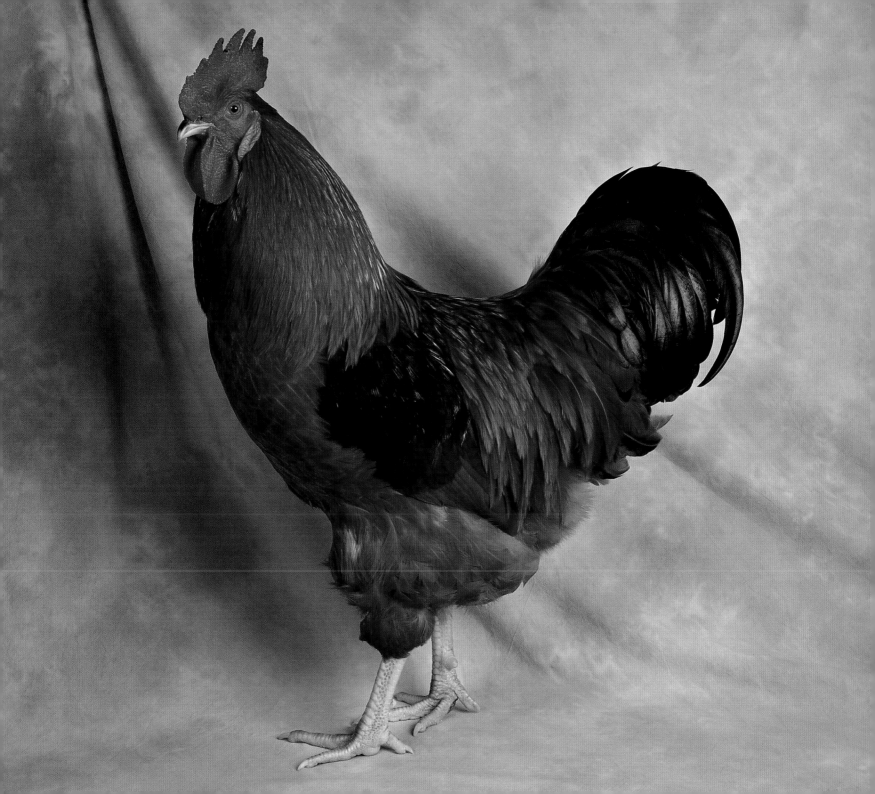

WELSUMMER

COCK

Classified as a large, soft-feather fowl, the WELSUMMER is an active breed with a calm, gentle temperament. Birds eagerly forage for food when given the chance, and both hens and cocks walk breast-forwards with a stately grace. Known for their iconic appearance, Welsummers are often featured in artistic depictions of farm life, and legend has it that the Kellogg's Cornflakes rooster was modelled after this breed.

Features

The Welsummer features a well-proportioned body, an arched back and a full tail carried high. The breast is nicely rounded and the head is medium sized. The male has a large red single comb with five well-defined points. The female's comb is similar but smaller. The red wattles are round and full, particularly in the cock. The breed has yellow skin and featherless shanks.

Use

The Welsummer is prized for both its beauty and its stunning bronze eggs. The hens are productive layers and their large eggs often have attractive dark speckles. Welsummers are excellent free-range birds and are known for their foraging talents.

Related Breeds

The Welsummer counts Cochin, Leghorn and Wyandotte varieties as its kin, and Barnevelders, Rhode Island Reds and Orpingtons may have also been used in the breed's development.

Size

Hen weight 2.7kg.(6 lb)

Cock weight 3.2 kg (7 lb)

Origin & Distribution

The Welsummer takes its name from the Dutch village of Welsum. A demand for the hens' dark brown eggs drove much of the breed's development. It was imported to Britain in 1928 and was accepted in the American Standards in 1991. Today it is found throughout the world.

Holland

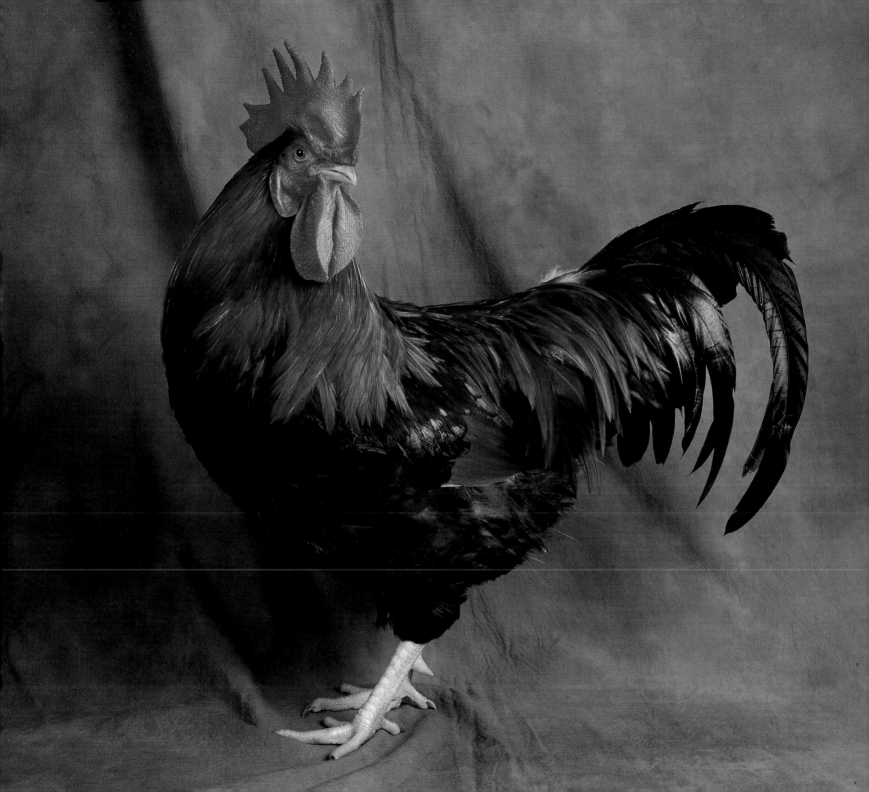

BARNEVELDER

HEN

The Barnevelder is a heavy, soft-feathered Dutch breed kept both for show and for utilitarian purposes. It takes its name from the Barneveld region of Holland where it was first developed via crosses between imported Asian breeds and local fowl. It is an alert, attractive fowl with a fine shape and calm temperament.

Features

The breed features a round, full breast, broad shoulders and a concave back. Barnevelders hold themselves tall and carry their short wings high. Their bright red ear lobes and wattles are medium sized and they have a single, upright comb with clear serrations. The tail is full and sweeping. Barnevelders come in four different colour types – black, partridge, silver and the double-laced (shown here).

Use

Barnevelders are reliable layers and are prized for their unique dark brown eggs. Their full bodies also make them a good meat breed and many raise them for dual-purpose use. They are easily tamed and do not fly much, so they make a good domestic back-garden bird. However, they are susceptible to Mark's disease, so must be vaccinated as chicks.

Related Breeds

The Barnevelder counts the Cochin, Brahma and Langshan breeds amongst its relatives.

Size

Hen weight 2.7–3.2 kg (6–7 lb)

Cock weight 3.2–3.6 kg (7–8 lb)

Origin & Distribution

The Barnevelder's attractive brown eggs gained it a large following and it was imported to Britain in 1921. The breed was also brought to the USA and was admitted into the American Poultry Association's *Standard of Perfection* in 1991. It's currently found across Europe, North America and Australia.

Holland

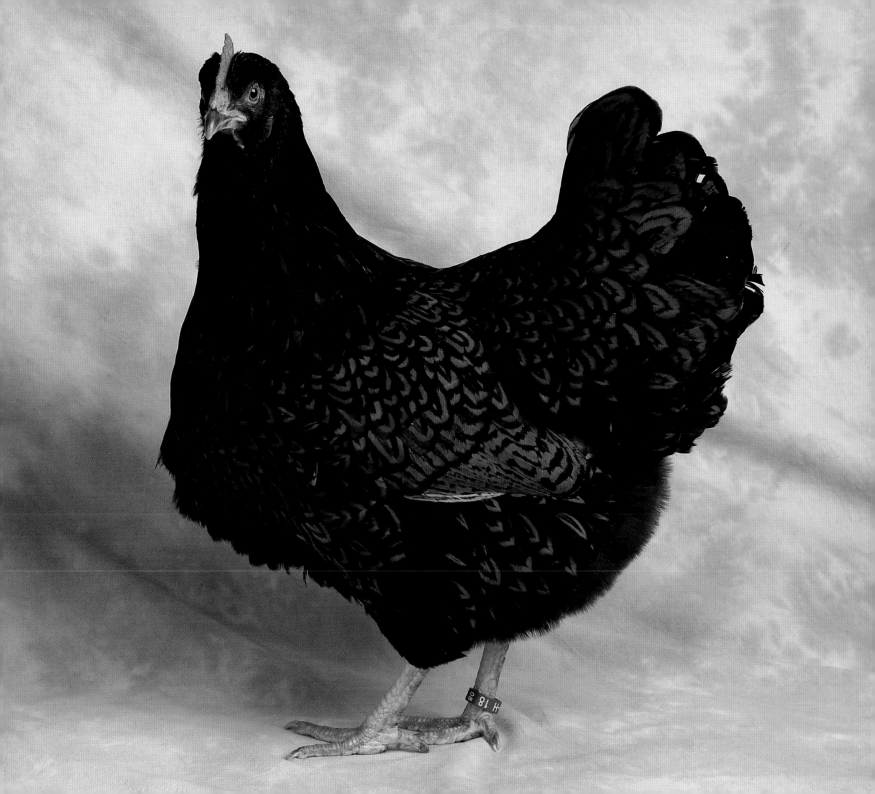

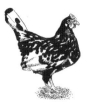

HAMBURGH

HEN

The HAMBURGH is a bustling breed with an animated personality. These fowl carry themselves with an effervescence that has captured the affection of many a garden keeper. Sprightly and vivacious, Hamburghs enjoy roaming free and are adept flyers. They easily recognise their human handlers, but are not especially tame.

Features

The breed has a compact body, well-rounded breast and a flat shape at its back. It carries its large wings close to the body and its long tail shoots upwards in a neat bunch. The head is small, but its eyes are big and bold. It has a medium-sized rose comb that tapers to a small spike covered in coral points. It comes in many feather colours and patterns including black, gold spangled, gold penciled, silver penciled and silver spangled (shown here).

Use

Too small for meat production, the Hamburgh was most likely developed as a layer, though its egg production has diminished somewhat as breeders have selected for its appearance. Still, it remains a hardy, reliable layer of small white eggs. Hamburghs mature fairly early and do not require as much feed as many breeds, since they prefer to forage when possible.

Related Breeds

At various times in its history the Hamburgh has been known as Moonies, Pheasants and Crescents. The breed was probably used in the development of the Rosecomb Bantam.

Size

Hen weight 1.8 kg (4 lb)

Cock weight 2.3 kg (5 lb)

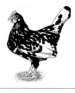

Origin & Distribution

The Hamburgh's development has long been credited to Dutch breeders, but the stock most likely originated somewhere in the eastern Mediterranean. Accounts of the Hamburgh are found in Britain as early as 1702. Today it is kept by enthusiasts throughout Europe and North America.

Holland

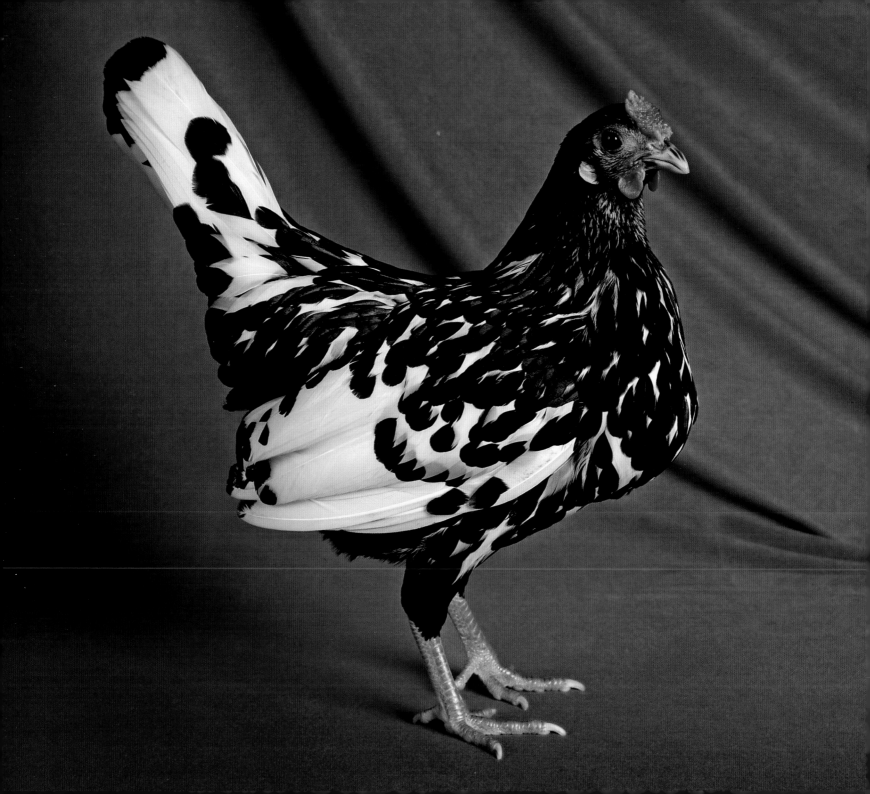

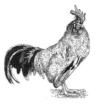

NANKIN

COCK

With no standard-sized equivalent, the Nankin is a true bantam. Today it is classified as a rare breed, but it was once one of Britain's most popular bantams, hence its other name: Common Yellow bantam. One of the most ancient of bantam breeds, the Nankin has oscillated between popularity and near extinction over the centuries.

Features

The Nankin stands with its breast tilted upwards and its head high. Its back slopes towards the tail and the wings are rather large for its size and carried low to the ground. The head is small with a moderate-sized single (as here) or rose comb. Plumage is a rich orange with chestnut, copper and ginger-buff colouring. Males have black feathers in the tail. The breed is known as vocal and active.

Use

Extremely easy to tame, Nankins make good pets. They lay tiny tinted eggs and the hens are such adept brooders that they are sometimes used as surrogates to incubate game fowl eggs, though they're rarely kept for purely utilitarian purposes. Nankin stock was also used in the development of the Sebright breed.

Related Breeds

As one of the first true bantam breeds, the Nankin played a role in the development of numerous other bantams, most notably the Sebright.

Size

Bantam hen weight 570–620 g (20–22 oz)

Bantam cock weight 680–740 g (24–26 oz)

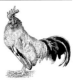

Origin & Distribution

The breed's early history is uncertain, but it arose somewhere in Asia, most likely Indonesia or Malaysia. It first arrived in Britain in the 1700s and has also been kept in North America, where it once faced extinction until enthusiasts took up its cause. Today it's raised by enthusiasts in Asia, North America and Europe.

Indonesia

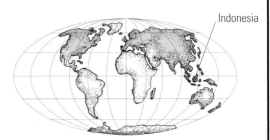

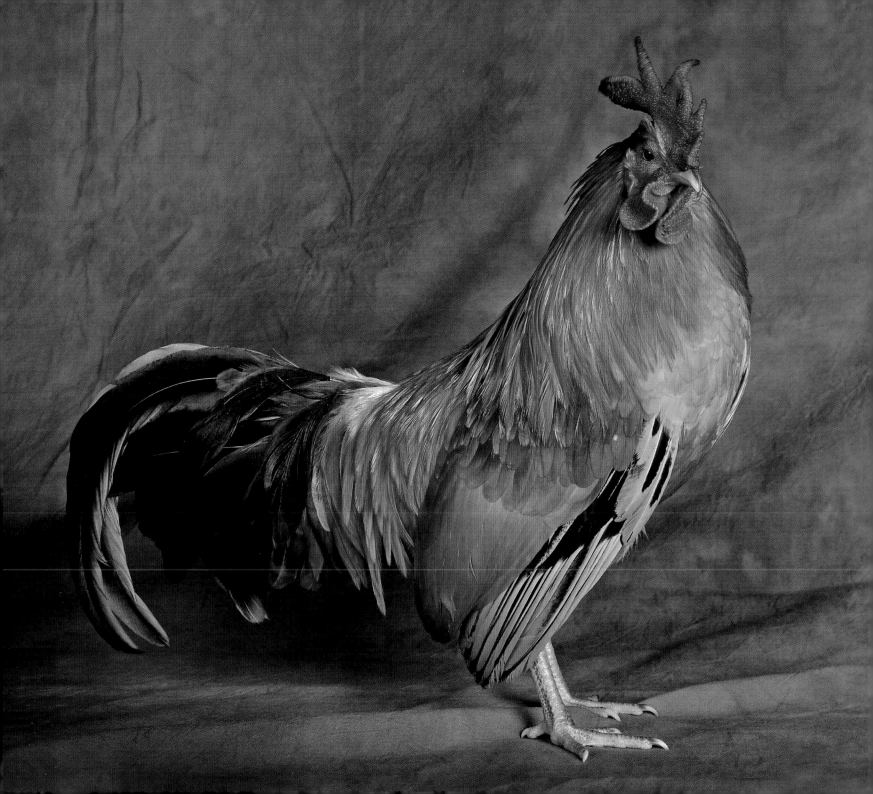

OLD ENGLISH GAME BANTAM
COCK

A confident, active breed, OLD ENGLISH GAME BANTAMS have a reputation for feistiness, and are often noisy. Yet generations of breeding for ornamental traits have reduced the breed's aggressiveness, and birds may become fairly tame when handled with patience. Old English Game Bantams need room to roam, as they enjoy foraging and do not thrive in confinement.

Features

This breed features a small, muscular body, a round breast and curved back. They have a single, five-pointed upright comb, which is usually dubbed or cut for exhibition. The ear lobes and wattles are small. The elegant tail stands upright from the back, with a small number of feathers curling downwards in a fan.

Use

Old English Game Bantams are kept mostly for ornamental purposes. They lay more consistently than many game breeds, but their eggs are small and often only seasonal. Hens are renowned for their brooding ability, a trait sometimes put to use by giving them foster eggs to incubate. The breed produces good meat for a game bird, although it is rarely raised for this purpose.

Related Breeds

The Old English Game Bantam's pedigree is not well known, but it is undoubtedly related to other game breeds developed in Britain.

Size

Bantam hen weight 510–620 g (18–22 oz)

Bantam cock weight 620–740 g (22–26 oz)

Origin & Distribution

This game breed originated in the 19th century from British fowl raised for cockfighting. When England outlawed cockfighting in the mid-1800s, breeders turned their attention to the birds' ornamental qualities. The Old English Game Bantam was admitted into the American Standards in 1928. Today it is kept by enthusiasts worldwide.

England

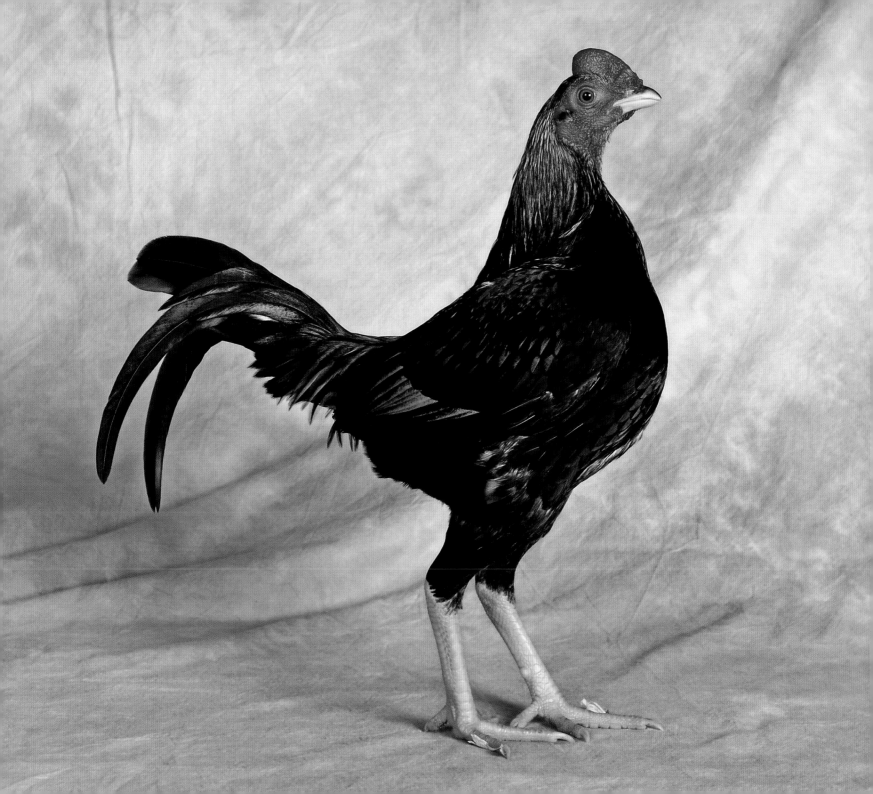

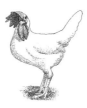

LEGHORN

HEN

Remarkably hearty and adaptable, the LEGHORN has long established itself as a superior laying breed, capable of putting out 270 or more eggs per year. The white Leghorn reigns as the top commercial laying fowl worldwide. Quick to reach maturity, the Leghorn begins laying early and rarely lets up. It is classified as a large, soft feather breed and birds have a flighty personality.

Features

Leghorns have a narrow neck, long body and flat, long back, which slopes to the tail. They can have either a single or rose comb, and when single, the comb may be enlarged and fold over to one side. Wattles are long and red. They come in an array of plumage colours including black, blue, brown, buff, cuckoo, golden duckwing, silver duckwing, exchequer, black mottled, red mottled, partridge, pile and white (shown here).

Use

Kept almost exclusively for eggs, Leghorns are prolific layers of medium- to large-sized white eggs. Leghorns are one of the world's most popular layer breeds, especially amongst commerical egg producers. They tolerate confinement and hens rarely go broody.

Related Breeds

Leghorns are a Mediterranean breed developed with the help of Minorca and Malay stock.

Size

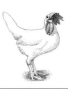

Hen weight 2.5 kg (5½ lb)

Cock weight 3.4 kg (7½ lb)

Origin & Distribution

The breed originated in Italy, but British breeders began crossing Leghorns with Malays and Minorcas in the late 1800s to increase their size and weight. They arrived in the USA shortly after, and made their way to Britain by the late 1800s. Today the Leghorn is found in poultry houses the world over.

Italy

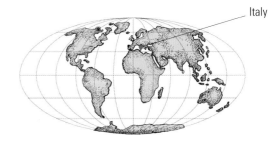

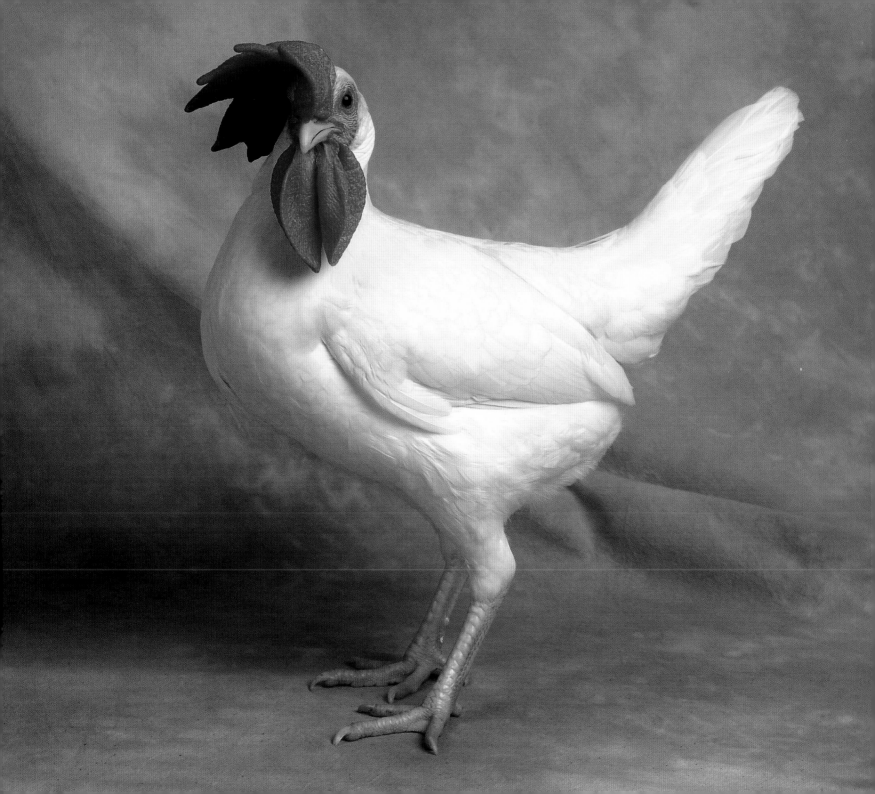

ARAUCANA

HEN

Its placid, easy-going nature and colourful eggs has made the ARAUCANA popular amongst garden keepers. This hen exhibits the lavender plumage type. The breed is closely related to the South American Rumpless, which has no tail. Breeding these two types has proven difficult, because the genes that produce the two breeds' unusual ear tufts (and lack of a tail in the Rumpless) also boost mortality in young chicks.

Features

Reliable layers, Araucana hens are often called 'Easter egg' chickens as they are prized for their beautiful green or blue eggs. The breed has a small pea comb and no wattles. The body is deep and long and the comb and face are a bright red. Tufts of feathers around their ear lobes give Araucanas their distinctive look. They are alert, active birds with an easy nature.

Use

Although often kept for its colourful eggs, the Araucana is a dual-purpose bird, suitable for meat production as well as eggs. Hens often go broody, but can make good mothers under the right circumstances. Araucanas have a gentle, hardy character.

Related Breeds

The Araucana is related to several South American breeds including Collonca, Quetero and the South American Rumpless.

Size

Hen weight 2.3–2.7 kg (5–6 lb)

Cock weight 2.7–3.2 kg (6–7 lb)

Origin & Distribution

The Araucana originated from poultry developed by breeders belonging to the indigenous Arauca tribe in northern Chile. George Malcolm created the British Araucana breed standard in Scotland in the early 20th century from stock imported from Chile. Today the Araucana is raised throughout the world, from South America to the Pacific Islands, Western and Eastern Europe, and Asia.

Chile

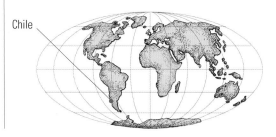

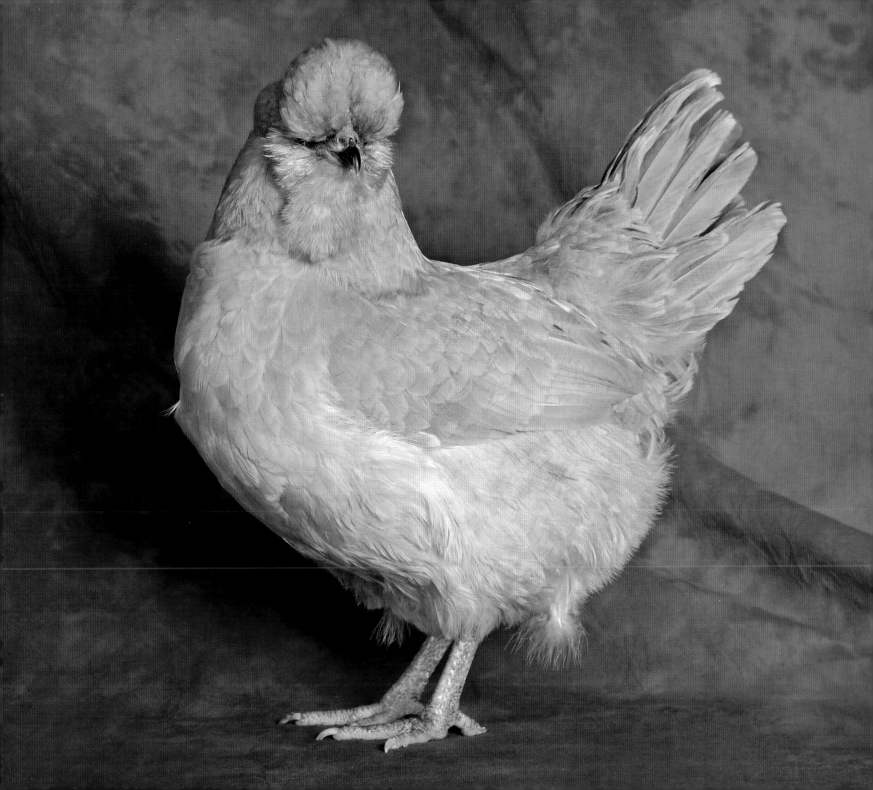

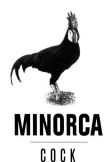

MINORCA
COCK

Known for its striking size and elegantly elongated wattles and ear lobes, the MINORCA is the largest Mediterranean chicken breed. It's an attractive fowl, but not especially docile. George Orwell's famous novel *1984* features several Minorca pullets leading a resistance movement. Centuries old, it has an iconic appearance and often turns up in farm-themed knick-knacks.

Features

Dark and tall, the Minorca has a squared chest and a long, rectangular body shape. The tail is carried in a horizontal position. The breed has a single comb, which stands tall in the cock and flops over in the female. Its distinguishing features are its long, drooped wattles and stark white ear lobes. The British Standards recognises three plumage colour types: black, white and blue.

Use

Developed as a laying breed, Minorcas initially gained wide recognition for their unusually large white eggs. Still kept mostly for eggs, Minorcas do not fare well in cold regions, as their oversized wattles and ear lobes are susceptible to frostbite, but they thrive in hot climates. Hens rarely brood.

Related Breeds

The Minorca is related to the White-faced Black Spanish, Castilian Black Langshan and White-faced Spanish.

Size

Hen weight 2.7–3.6 kg (6–8 lb)

Cock weight 3.2–3.6 kg (7–8 lb)

Origin & Distribution

The Minorca is a very old breed that originated in Spain as early as the 17th century. It was subsequently refined by British breeders in the 1700s and 1800s. Later it made its way to North America and it is now found in Europe and North America.

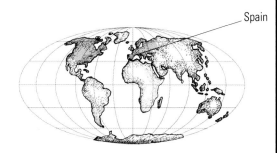

Spain

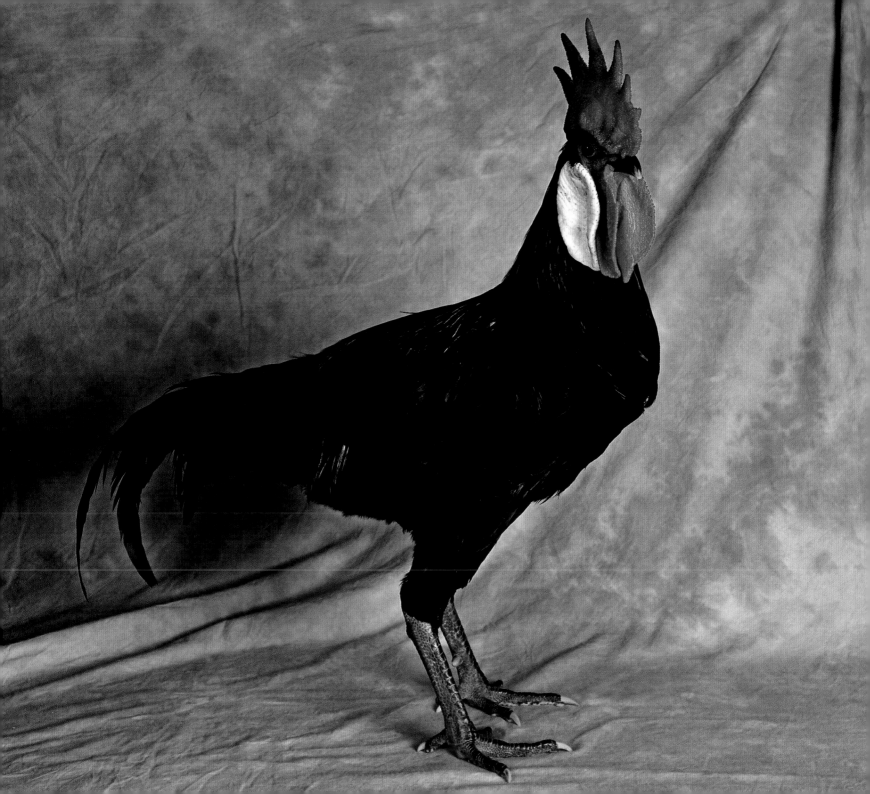

JAPANESE BANTAM
COCK

The Japanese Bantam is a true bantam, with no standard-sized equivalent. It is a showy bird with the shortest legs of any variety. What the legs lack, the tail make up for with its extreme length. Despite their unusual shape, Japanese Bantams make good fliers and enjoy foraging. They are amongst the most popular bantam breeds, but it is difficult to maintain their prized features.

Features

Japanese Bantams stand low on stubby legs and their full, deep breasts skirt the ground. Their heads are small and topped by a prominent single red comb with distinct serrations. The breed has red eyes and long red wattles. Plumage comes in more than twenty types, including mottled, grey, frizzled, birchen grey and the prized black-tailed white shown here.

Use

The Japanese Bantam is raised purely for show. This ornamental breed is amongst the most beautiful of all chicken breeds, but it is also amongst the least practical. Because it is low to the ground, it does not fare well outdoors in mucky weather and the breed is not especially cold hardy.

Related Breeds

The Japanese Bantam was developed centuries ago from ancient Malaysian breeds.

Size

Bantam hen weight 400–510 g (14–18 oz)

Bantam cock weight 510–570 g (18–20 oz)

Origin & Distribution

As its name implies, the Japanese Bantam originated in Japan. It is seen in Japanese art from the early 1600s and in European art shortly thereafter. The breed probably arose from Malaysian fowl. Today Japanese Bantams are popular worldwide.

Japan

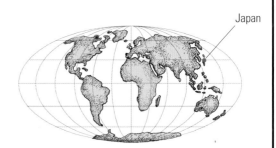

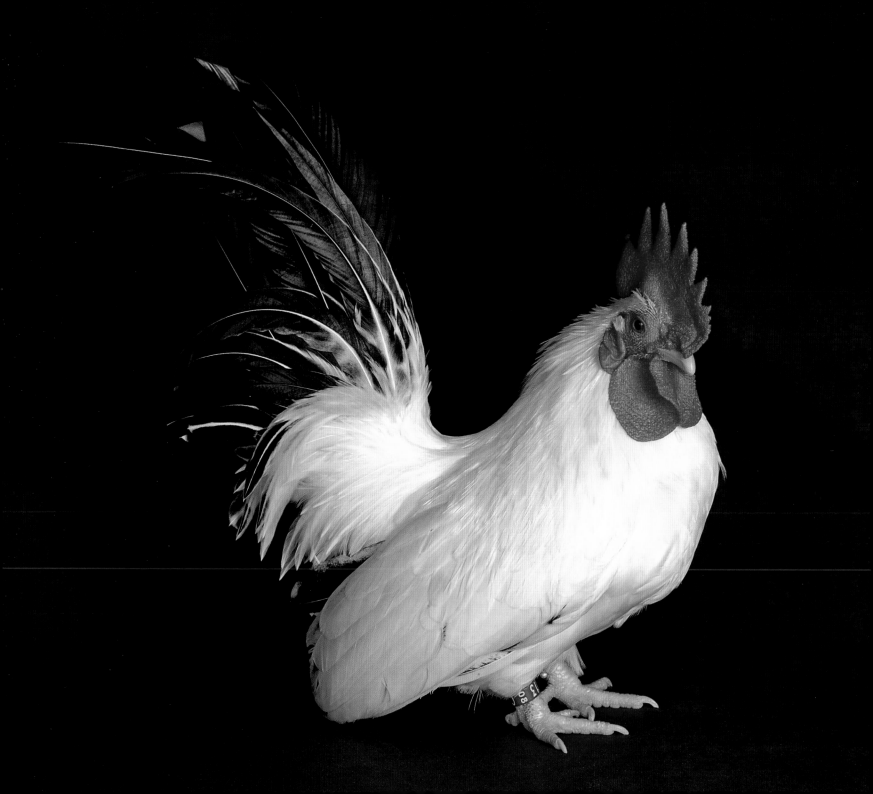

MARAN

COCK

Known as a mellow, tidy breed, MARANS are famed for their large, chocolate-coloured eggs. The breed has short, heavy 'hard' feathers usually associated with game fowl. It is currently listed in the *British Poultry Standards*, but not yet recognised by the American Poultry Association, although a movement is underway to rectify that.

Features

The Maran features a wide body with a broad breast and a full tail, carried high. The medium-sized head has an erect single comb and the breed has fine, medium-sized wattles that in males hang well below the beak. Ear lobes are red and less distinctive than the wattles. The British Standards lists four plumage colours: black, dark cuckoo (shown here), golden cuckoo and silver cuckoo.

Use

Kept mostly for its stunning, dark brown eggs, the Maran also makes a decent meat bird, as its flesh is firm and white. The breed is fast-growing, docile and easy to keep. The genes that produce the egg colour can also lead to an unfavourable appearance, so breeders are constantly fighting the desire to produce dark eggs with the need to create shapely combs and plumage.

Related Breeds

The Maran has many related breeds including Croad Langshan, Faverolles, Barred Rock, Brakel and Coucou de Malines.

Size

Hen weight 3.2 kg (7 lb)

Cock weight 3.6 kg (8 lb)

Origin & Distribution

The Maran takes its name from the French village of Marans where the breed arose from crosses between local fowl and poultry that arrived via trade ships that docked in the local port. It came to Britain around 1929 and is now found in North America.

France

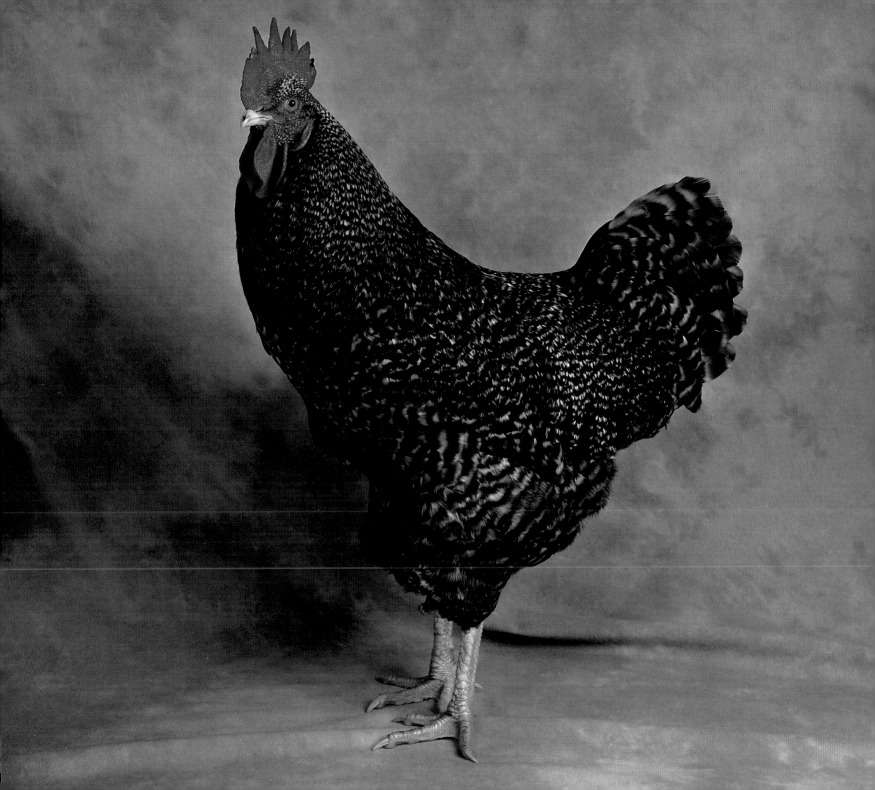

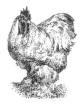

COCHIN

COCK

Cochins are docile and easy to keep. They caused a sensation, the so-called 'Cochin craze', in the 1880s when this breed with ridiculously fluffy feathers became a must-have item for fowl lovers across Europe and North America. Whilst most poultry at that time was kept for production, these full-feathered birds were sought for their showy appearance. Unlike many large fowl, the breed has no bantam equivalent.

Features

The Cochin looks like a ball of feathers. Its abundant plumage and large, broad body give it the appearance of even more heft than it actually possesses. The breed has a short, wide back and a low, broad breast, with small wings held close. Cochins have a single red upright comb and thin, pendant wattles. Plumes of feathers cover the shanks and feet.

Use

At the height of their popularity, Cochins were kept for their good looks. They also make decent meat birds, but take a little more time to mature than many commerical breeds. Hens make good mothers and layers, continuing to lay eggs through the winter.

Related Breeds

Cochins are one of the largest breeds and they were used to create several other breeds of big birds including Brahmas and Orpingtons.

Size

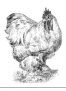

Hen weight 4.1–5 kg (9–11 lb)

Cock weight 4.5–5.9 kg (10–13 lb)

Origin & Distribution

Originally called Shanghai, a nod to its Chinese origins, the Cochin has also been known as the Cochin-China. The breed was developed in China in the mid-1800s. Its popularity has fallen since its heyday, but it is still a popular choice for fanciers around the world.

China

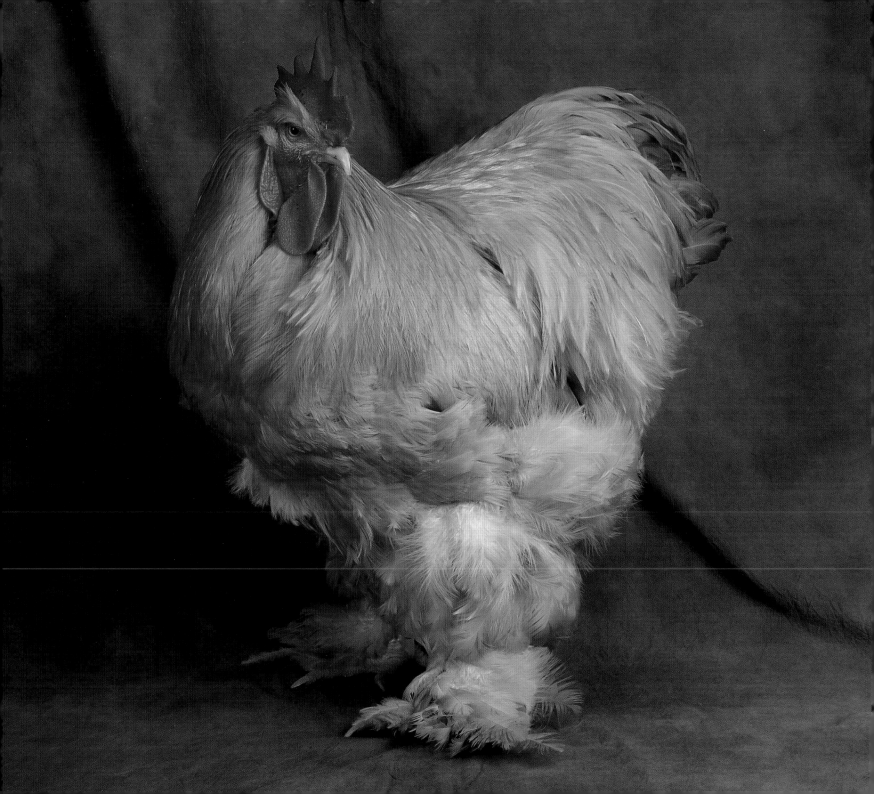

SUSSEX

HEN

The Sussex is a lithesome fowl classified as a heavy, soft feather breed. Known for their calm demeanour, these are docile birds that are easy to tame and gentle with children. They make superior domestic garden fowl, as males are less aggressive than many other breeds, and because they do not readily fly, they are easy to contain.

Features

The Sussex has a broad breast, flat back and wings carried close to its body. It has a single red comb that is medium sized with even serrations. Wattles and ear lobes are also red and moderate sized. The *British Poultry Standards* includes eight different colour types: brown, buff, coronation, red, speckled, silver, white and light (shown here). The Sussex's tail forms a 45-degree angle with the body and is medium sized and unadorned. Its short shanks are featherless with four toes.

Use

Considered a dual-purpose breed, the Sussex provides satisfactory meat and a steady source of tinted eggs. Hens continue laying throughout the winter and make doting mothers. Offspring mature rather quickly. The breed tolerates confinement but also does well free range.

Related Breeds

Breeds used to develop the Sussex include the Brahma, Cochin, Old English Game Bantam and Dorking. The Sussex and Dorking may have been classed as the same breed at one time, until the two were split off, those with four toes being called Sussex and those with five classified as Dorkings.

Size

Hen weight 3.2 kg (7 lb)

Cock weight 4.1 kg (9 lb)

Origin & Distribution

The Sussex takes its name from its place of origin: Sussex in England. The breed was listed in British poultry shows as early as 1845. Today it is shown in North America and Europe.

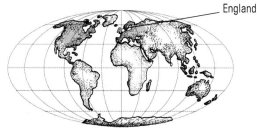

England

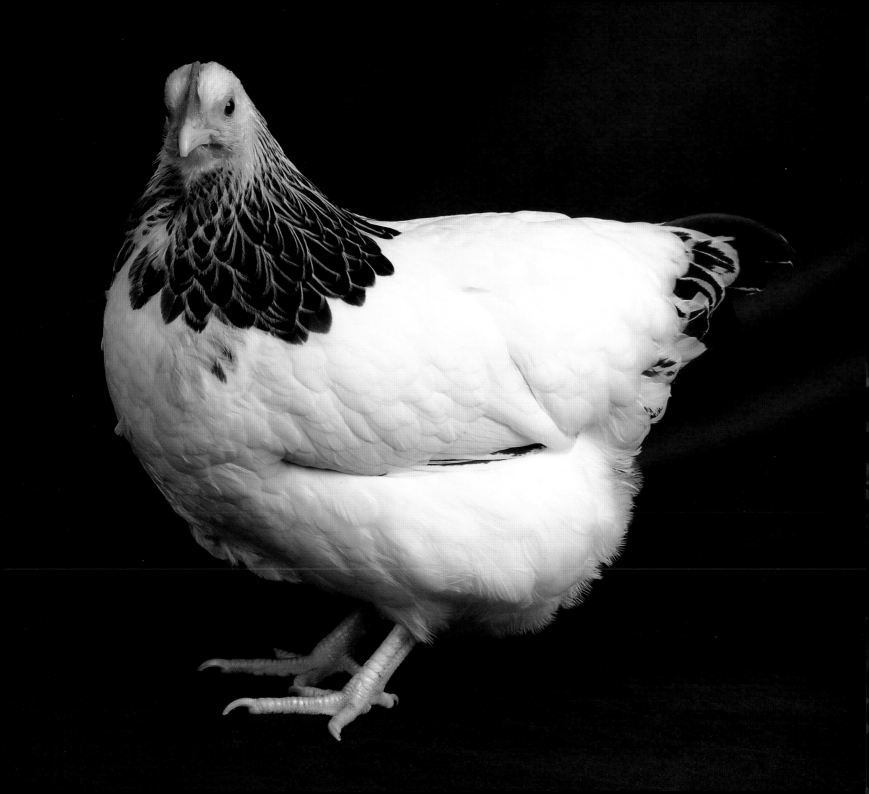

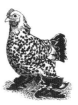

BOOTED BANTAM

HEN

The Booted Bantam is a very rare, true bantam breed. Its name is derived from the bird's extravagant feathering on the feet and hock joints. Called Federfussige Zwerghuehner in Germany and Sabelpoot in Holland, the Belgians crossed the breed with Barbu d'Anvers to produce Barbu d'Uccles. The Booted Bantam carries itself in a confident, almost strutting manner.

Features

This breed's body features abundant saddle feathers, large wings and a full, upright tail. An erect, single comb sits atop its head, which also features small, fine wattles and ear lobes. The Booted Bantam comes in a wide array of colour types including black, white, black mottled, blue, cuckoo, lavender, millefleur, porcelaine, silver millefleur and lemon millefleur sable poot (shown here).

Use

These are ornamental birds, kept by enthusiasts and exhibitioners. Hens lay tinted eggs, but they are small and the birds are too small to provide much meat. Those who keep these unusual fowl are often drawn by the Booted Bantam's showy, flamboyant looks and elegantly feathered feet.

Related Breeds

The Booted Bantam is one of a family of Belgian bantams that includes the Barbu d'Anvers and Barbu d'Uccles.

Size

Bantam hen weight 850 g (27 oz)

Bantam cock weight 860 g (30 oz)

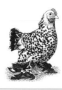

Origin & Distribution

This breed was developed in Europe at least a century ago, but it has always been somewhat rare even in its place of origin. Today it has fanciers in Europe, North America and Australia.

Belgium

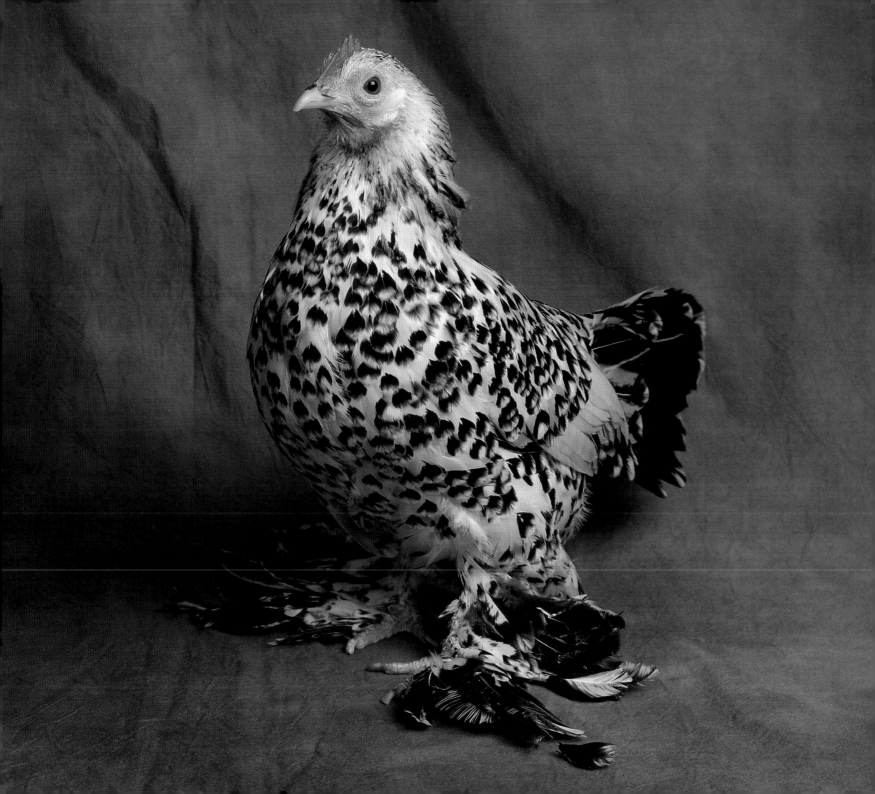

BRAHMA
COCK

A soft-feather fowl, the BRAHMA is prized as one of the world's largest chicken breeds, earning it the moniker 'King of Poultry'. Vigorous and sturdy, it has also developed a reputation as the USA's most popular meat breed for nearly seventy years, beginning in the mid-1850s when the Breed fuelled a poultry craze in both that country and in Britain, known as 'hen fever'.

Features

Though the modern Brahma no longer reaches the 8-kilogram-(18-pound)-plus range documented at the height of hen fever, its huge size remains its most distinctive feature. The breed has a square, broad body and full, horizontal keeled breast. Both sexes have pea combs and long red ear lobes. Medium-sized wings rest under the long saddle feathers and the tail stands upright.

Use

The breed's large size makes it a popular meat fowl. Hens are not especially prolific layers, but reliably produce tinted eggs well into the winter months. Brahmas adapt well to most climates, as they tolerate both heat and cold. They have a calm temperament and can adjust to confinement.

Related Breeds

The Brahma was developed in the USA from a heavy Chinese breed known as Shanghai and a kind of Malay known as the Grey Chittagong.

Size

Hen weight 3.2–4.1 kg (7–9 lb)

Cock weight 4.5–5.4 kg (10–12 lb)

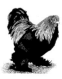

Origin & Distribution

The Brahma's name comes from the Brahmaputra River in Asia. After disputes about what to call the breed, a group of judges met in Boston in the USA in 1852 and gave it an official name of Brahmapootra, which was eventually shortened to Brahma. The breed was admitted into the British Standards in 1865.

USA

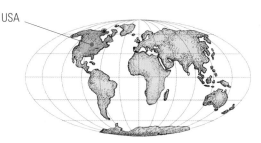

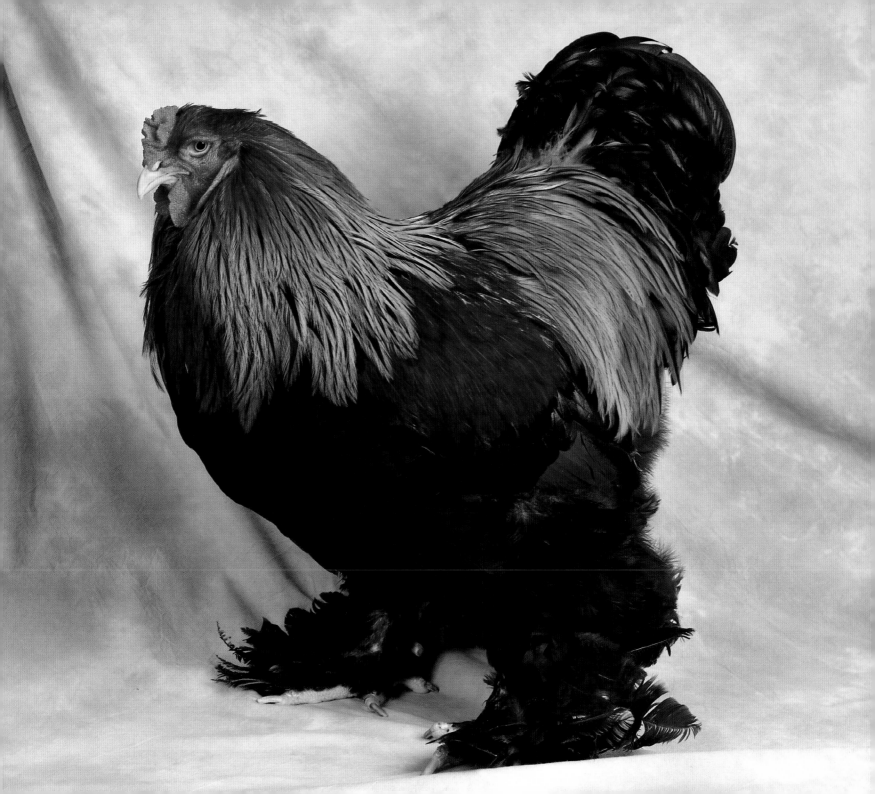

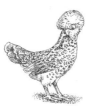

POLAND

HEN

The POLAND is one of the world's oldest and most popular crested breeds. Docile and fairly calm, they tolerate confinement better than many breeds. The gaudy crest of head feathers can impair their vision, and as a result they may startle easily. The Poland's crest feathers are not especially practical in cold weather and their limited vision makes them vulnerable to predators.

Features

The Poland's most noticeable feature is the crest of feathers on its head, ornate and over the top, like a Las Vegas showgirl. The breed carries itself with a stately, tall posture, and its breast is round and forwards, whilst the tail is full and tall. The wattles and ear lobes may be completely obscured by the crest. The face may be smooth or entirely covered with muffling, as seen here.

Use

Considered an ornamental breed, the Poland is kept mostly for show or as a pet. Egg production may be unpredictable, and eggs are not especially large. Hens rarely brood and are not known as good mothers. Chickens sometimes suffer from health problems. Still, their unusual looks make them popular amongst hobbyists.

Related Breeds

The Poland's heritage remains a bit of a mystery, but it is most likely related to Paduan or Patavinian fowl.

Size

Hen weight 2.3 kg (5 lb)

Cock weight 2.9 kg (6½ lb)

Origin & Distribution

Whilst its name suggests that this breed originated in Poland, its actual origins are not entirely clear. It is thought to have arisen in the 16th century, and the breed as it exists now probably came from Holland, though it may have some roots in its eponymous country. It is now a popular ornamental breed around the world.

Holland

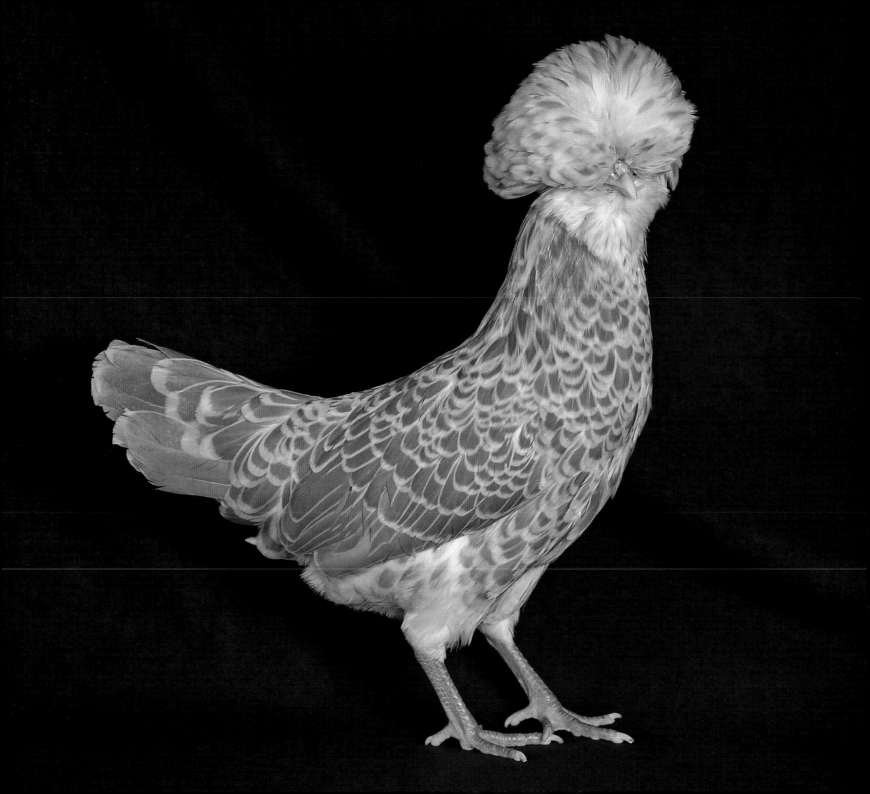

KO SHAMO
COCK

The Ko Shamo is a type of small Japanese game fowl bred to thrive in close quarters. It's a true bantam breed, noted for its unique split wings. The breed is also remarkably tall for its bantam size, and this height lends it a striking appearance. The breed's characteristic stance underscores its aggressive, strong temperament and it is known for its confident manner.

Features

The Ko Shamo's unusual profile is not easily confused. It has a tall, upright posture, and sparse, hard feathers. Its towering profile makes the neck appear especially long, and the muscular, lean body and breast are held perpendicular, rather than parallel to the ground, ending in a small 'prawn-like' tail. The head is strong and high and the feathers short and hard.

Use

Bred mostly for show, the Ko Shamo is too small to provide much meat, and hens lay only briefly; when they do, the white eggs are small and unremarkable. Suitable as pets, the breed does well in limited spaces, provided that multiple males are not housed in proximity, as males tend to fight with abandon.

Related Breeds

The Ko Shamo was developed in Japan and shares its genetic heritage with several other Japanese breeds such as the Nanking Shamo, the Malay and the Yokohama.

Size

Bantam hen weight 800 g (1¾ lb)

Bantam cock weight 1 kg (2¼ lb)

Origin & Distribution

The word *shamo* means 'fighter' in Japanese and reflects this bird's Japanese heritage. Ko Shamos were developed in Japan, most likely from stock imported from Thailand in the 16th or 17th century. It reached Europe in the 1970s. Whilst uncommon, it is now kept by fanciers in Asia, Europe and North America.

Japan

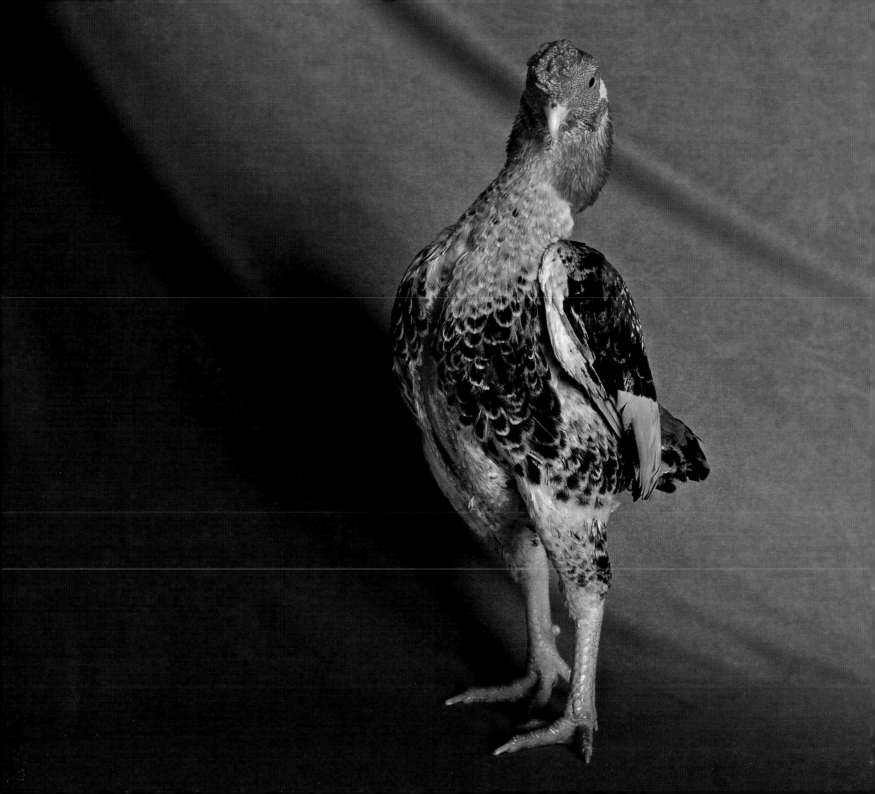

SEBRIGHT BANTAM

COCK

The Sebright Bantam is a true bantam with no standard equivalent. It is an ornamental breed developed especially for its attractive plumage, its remarkable beauty having made Sebright Bantams one of the most widely kept bantams. These fowl are spry and easily tamed, but are not easy to keep, as they are more fragile and difficult to breed than most varieties.

Features

Sebright Bantams have a compact body, broad breast, short arched back and long wings carried low. Their tails stand upright and square, extending above the back. The breed has a rose comb with fine points and nicely rounded wattles. Flat, unfolded ear lobes sit close to the face; legs are short and slender. Sebright Bantams have two colour types: gold, and silver (shown here).

Use

The Sebright Bantam is not a particularly practical fowl. Being bantams, they make poor meat birds, and hens lay only intermittently and rarely go broody. The breed's fertility is low as it suffers from poor hatch rates and chicks are not especially hardy. Their beauty makes them popular amongst hobbyists.

Related Breeds

The Sebright Bantam was developed via crosses with various bantam breeds, including Nankins and Polish types. The breed was later used in the development of Wyandottes.

Size

Bantam hen weight 510 g (18 oz)

Bantam cock weight 620 g (22 oz)

Origin & Distribution

This breed is named after its developer, British Parliament member Sir John Sebright, who created the breed around 1800. It soon made its way to North America and was admitted into the American Poultry Standards in 1874. Today it is prized by bantam fanciers around the world.

Britain

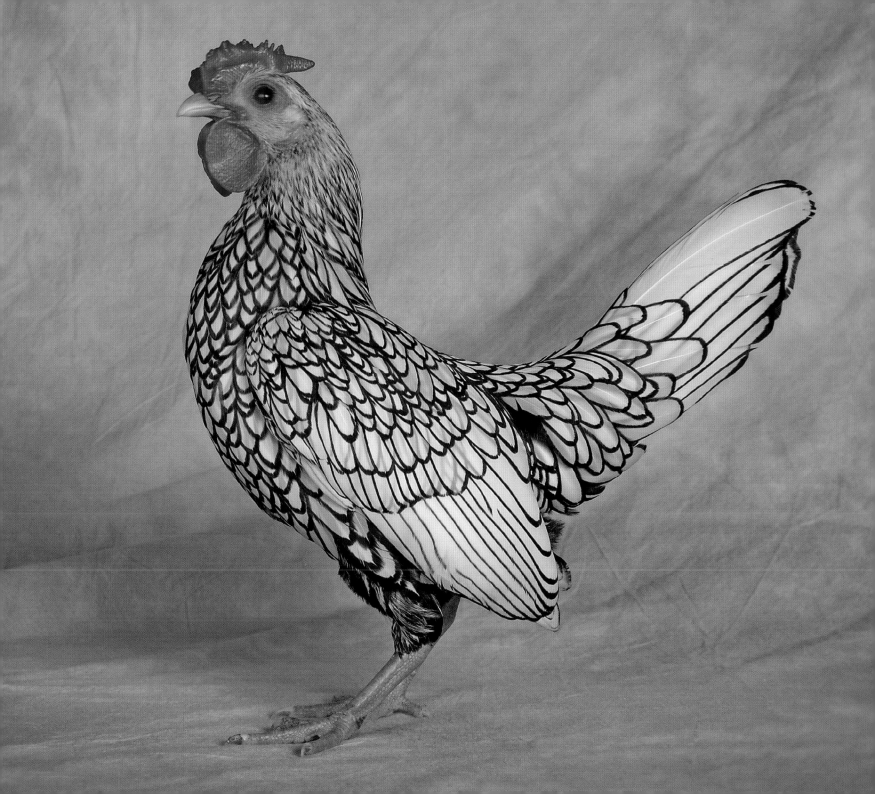

MODERN GAME

HEN

The MODERN GAME is a distinctive breed that carries itself in an erect manner, as if trying to win a height contest. Its arched neck curves elegantly into its sleek body. Originally bred from established fighting breeds, the bird's plumage comes in a variety of colours and patterns including golden white, blue, black, barred, birchen, cuckoo, wheaten, silver and brown-red (shown here).

Features

Tall and lanky, the Modern Game stands upright on long, muscular legs. The breed is known for its slender, vertical chest and straight back, which tapers to an elongated tail. Its head features a small red comb with upright points and diminutive red wattles and ear lobes. Famously aggressive and noisy, the breed is also naturally curious and active.

Use

This breed is kept and bred entirely for show. It requires ample room to roam, prefers high perches and does not tolerate cold weather. The breed's slender bodies make them poor meat birds. Hens are not prolific layers, but they are capable brooders.

Related Breeds

The Modern Game evolved from breeding Malay birds with Old English Game Bantam.

Size

Hen weight 2 kg (4½ lb)

Cock weight 2.7 kg (6 lb)

Origin & Distribution

The Modern Game originated in England from cockfighting stock. After cockfighting was outlawed in the mid-1800s, breeders sought exhibition uses for their game birds and the Modern Game arose from selective crosses between the Old English Game Bantam and the Malay. Today the birds are found throughout North America and Europe.

England

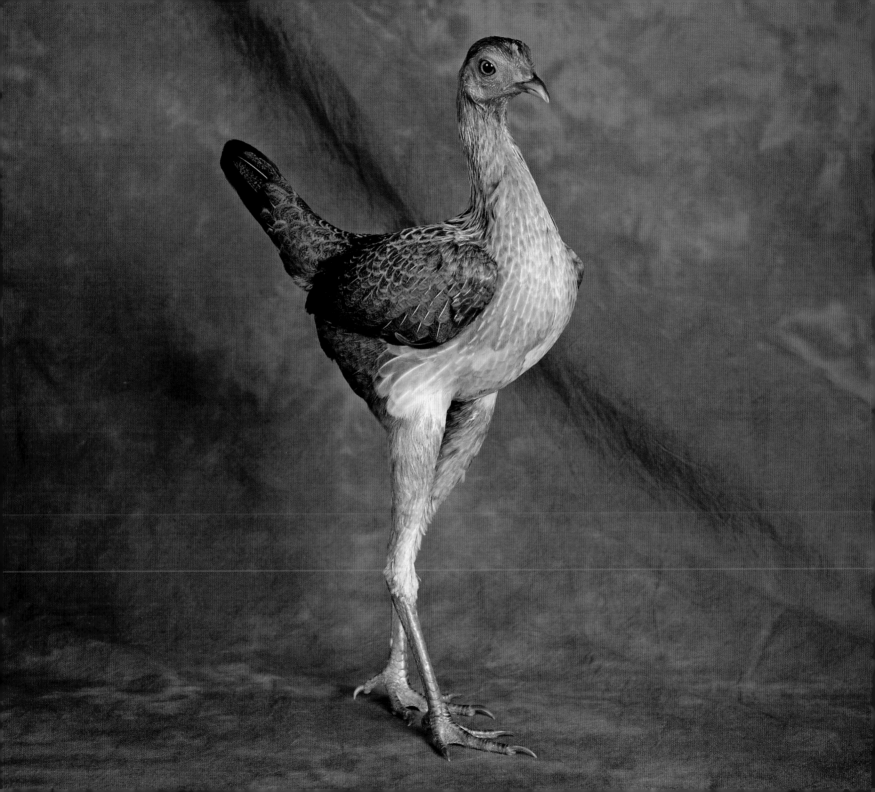

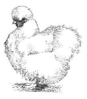

SILKIE

HEN

Renowned for its looks and personality, the SILKIE is a suave breed that carries itself with a lively, stylish posture. The fowl's gentle, trusting nature and trainability makes it a popular pet breed. Despite its diminutive size, the Silkie is categorised as a large fowl light breed, and so is exhibited in large rather than bantam classes.

Features

The Silkie's characteristic features are its silky, fur-like feathers and its puffy, hat-like crest. The breed features a broad body and short legs, mostly obscured by profuse plumage. The tail is short and tattered looking. All Silkies have the distinctive crest and some also exhibit a similarly puffed beard beneath their beak. The *British Poultry Standards* lists five colour types: partridge, black, blue, gold and white (shown here).

Use

Often kept as a pet, the Silkie is purely an ornamental breed. Silkie hens lay tinted or cream-coloured eggs and are so prized for their broody nature that they are sometimes used as foster mothers or crossed with other large breeds to increase the broodiness of these other types.

Related Breeds

The Silkie descended from Asian stock, but its family tree is unknown.

Size

Hen weight 1.4 kg (3 lb)

Cock weight 1.8 kg (4 lb)

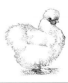

Origin & Distribution

Though known to hail from Asia, whether the Silkie originated from China, India or Japan remains in doubt. What is certain is that it is an old breed — legend holds that Marco Polo described observing Silkies during his Asian travels in the 13th century. Today the breed is raised by fanciers throughout Europe, North America and Australia.

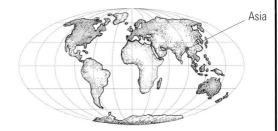

Asia

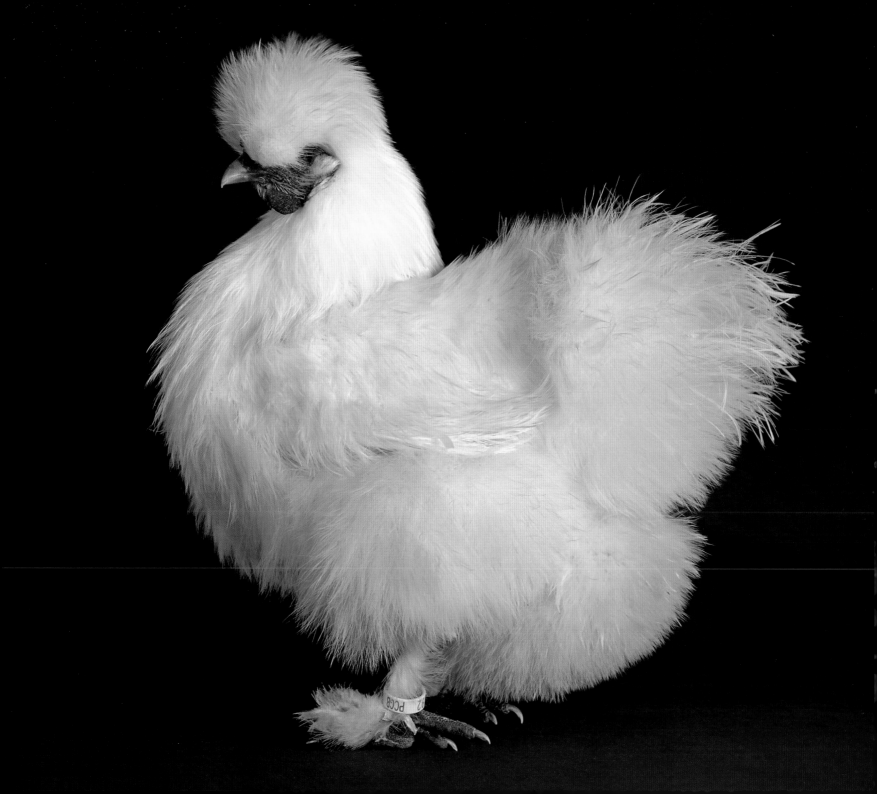

MALAY
COCK

The MALAY is one of the oldest breeds in Britain, and it was the first breed ever turned into a bantam, a development that occurred around the turn of the 20th century. Easily tamed and often affectionate towards human keepers, Malays can be quite aggressive at times towards their own kind and do not do well in large groups.

Features

Like most game birds, the Malay has hard feathers. These fowl have a distinctive upright posture and are amongst the tallest chicken breeds in existence. Their legs are remarkably long, just like their necks. They have sloping, rounded breasts and an erect stance, whilst the tail is narrow and moderate in size. Malays have overhanging eyebrows, which can make them look stern, and their small strawberry comb sits forwards on the brow.

Use

Malays are kept mostly for their looks, though they are sometimes raised for meat as well. Hens lay tinted eggs, but their egg production is unreliable and often short-lived. An active breed, they take more time to mature than others and do best with ample room to roam.

Related Breeds

The Malay most probably descended from Asian fowl that have since become extinct. It has been used in the development of numerous large breeds including the Scots Dumpy and Indian Game.

Size

Hen weight 4.1 kg (9 lb)

Cock weight 5 kg (11 lb)

Origin & Distribution

The Malay originated in Asia, and was imported to Britain as early as 1830. It features in the 1865 *British Book of Poultry Standards*, and has been developed into its modern form by breeders in Germany and Britain. Today it is kept by fanciers around the world.

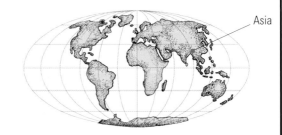

Asia

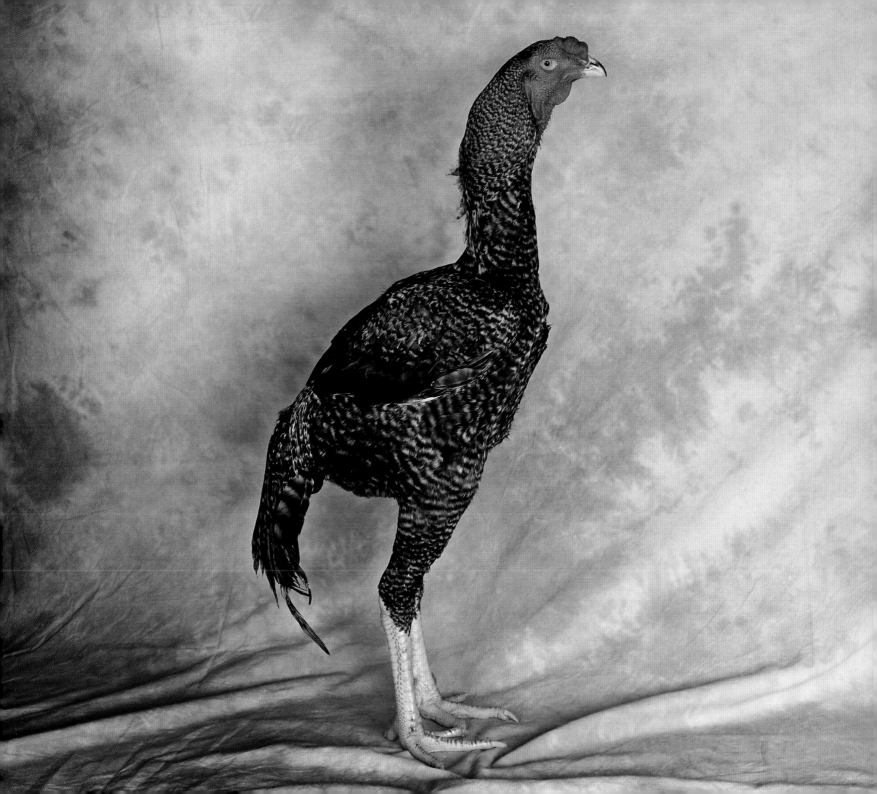

ANCONA
COCK

The Ancona is attractive enough to have gained favour as an exhibition bird, yet still practical for the farm. The Ancona is a distinct breed, known for its striking plumage and ability to withstand cold. Its distinctive spotted plumage pattern and Leghorn-like shape means that it is sometimes erroneously referred to as the Mottled Leghorn.

Features

Anconas can have either a single, upright comb with distinct serrations (as pictured here), which sometimes cascades to one side of the head like an elegant headdress, or a Wyandotte-like rose comb. Males have elongated red wattles and large white ear lobes, whilst hens usually exhibit smaller, rounded wattles and unremarkable oval ear lobes. They have a rounded, forward breast and large wings, which they carry upright.

Use

Anconas are prized for their prolific production of white eggs. They are often flighty, which can make them difficult to confine but may improve their ability to evade predators. Adept foragers, Anconas are popular amongst domestic garden keepers, because they provide good bug control and are reliable layers that rarely go broody.

Related Breeds

The Ancona is thought to be most closely related to the mottled Leghorn, and it is occasionally referred to as the black mottled Leghorn.

Size

Hen weight 2.2–2.5 kg (5–5.5 lb)

Cock weight 2.7–2.9 kg (6–6.5 lb)

Origin & Distribution

Developed in Italy, this breed gets its name from the port city of Ancona, from which it was first exported to England in the mid-1800s. It made its way to the USA, where it was admitted into the American Poultry Association in 1998. Today the breed is popular with poultry clubs in the USA, Britain and Australia.

Italy

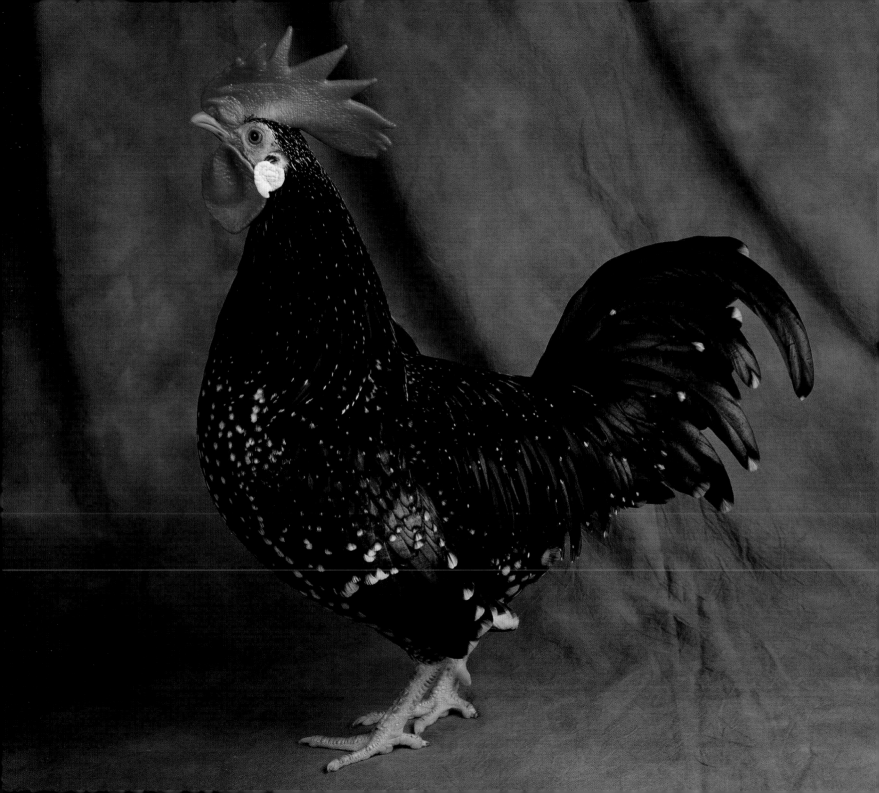

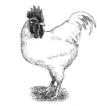

AUSTRALORP
COCK

Not just a pretty bird, the AUSTRALORP is treasured for its utility as a dual-purpose fowl. Considered a soft-feather heavy breed, Australorps are gentle, calm and amicable, easily tamed and fast to mature. Hens may begin laying as early as five months. Due to their large bodies, they are not very adept fliers and thus are rather easy to confine, though they enjoy foraging.

Features

The Australorp has an upright posture and carries its head high. The compact tail also rises tall above the short back, and the round chest is held forwards. A medium-sized single comb stands erect, with four to six serrations, and the ear lobes are small and elongated. This breed has soft plumage with minimum fluff, and includes three colour types: black, blue and white (shown here).

Use

With their hefty bodies and light skin, Australorps make good meat fowl, but they are also prolific, reliable layers. Hens can lay more than two hundred high-quality brown eggs per year, and the World Poultry Congress once honoured the Australorp as one of the world's most important utility fowl.

Related Breeds

The Australorp is related to many other modern breeds, including the Orpington, Minorca, Plymouth Rock, Lanshan and Leghorn.

Size

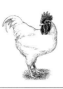

Hen weight 2.9–3.6 kg (6½–8 lb)

Cock weight 3.9–4.6 kg (8½–10 lb)

Origin & Distribution

The Australorp is thought to have been bred in Great Britain from a superior strain of Black Orpingtons imported from Australia in the early 1900s. The name is a contraction of Australian Black Orpington. Today it is popular worldwide.

Britain

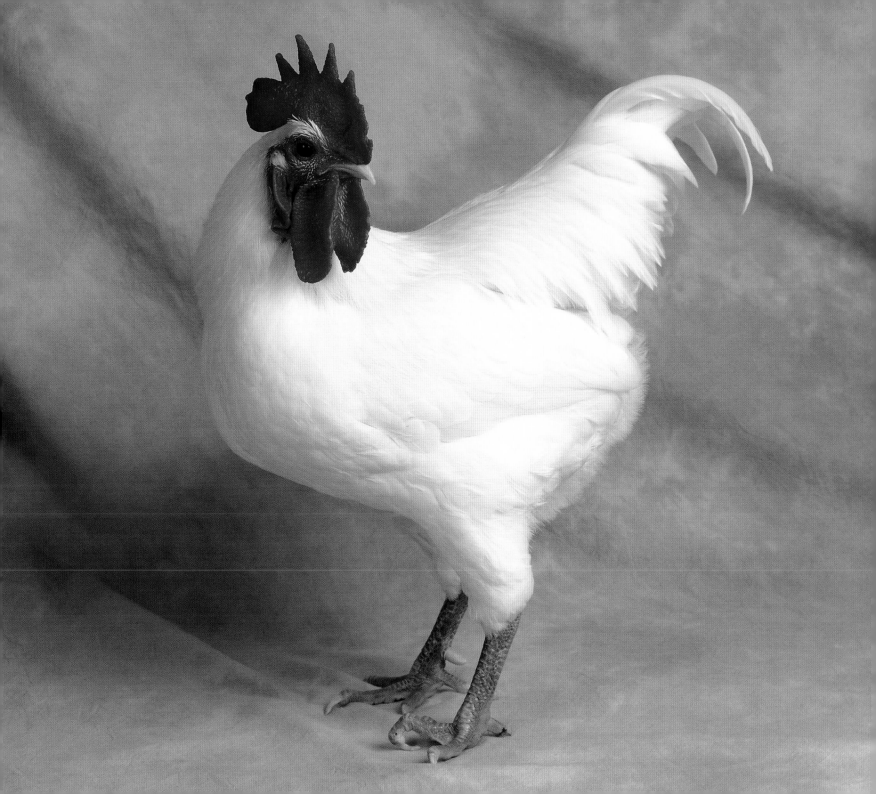

APPENZELLER SPITZHAUBEN

HEN

The Appenzeller Spitzhauben is a rare, ornamental breed that is well adapted to the cold, snowy weather of its native Switzerland. Given the chance, it will gladly roost outside on a tree branch, even in poor weather. The word 'spitzhauben' means 'pointed hoods' in German, referring to the feathery flourish that pours from the bird's head, like a Las Vegas showgirl's headpiece.

Features

The Appenzeller Spitzhauben wears a distinctive red V-shaped comb and long, round wattles. Its white ear lobes are medium sized and its small head is dwarfed by the fountain of upright feathers that grow from the end of the comb to the back of its head. Its tail is long and spread. It is mostly seen as standard sized, though bantams are possible. It comes in silver spangled (shown here), gold spangled, chamois spangled, black and blue.

Use

An ornamental breed, the Appenzellers are kept for their looks, not their production value. Hens lay a reasonable number of white eggs. The breed's small size make them poor meat birds, but they are excellent foragers and very self-sufficient.

Related Breeds

Appenzeller Spitzhauben are related to the Appenzeller Barthuhner and Brabanter breeds.

Size

Hen weight 1.6 kg (3½ lb)

Cock weight 2 kg (4½ lb)

Origin & Distribution

Originating in the Appenzell canton of north-east Switzerland in the 16th century, the modern history of the breed remains relatively unknown. A few dedicated breeders in Germany and the USA probably kept the breed from disappearing, and today Appenzellers are found throughout North America and Europe.

Switzerland

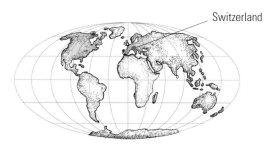

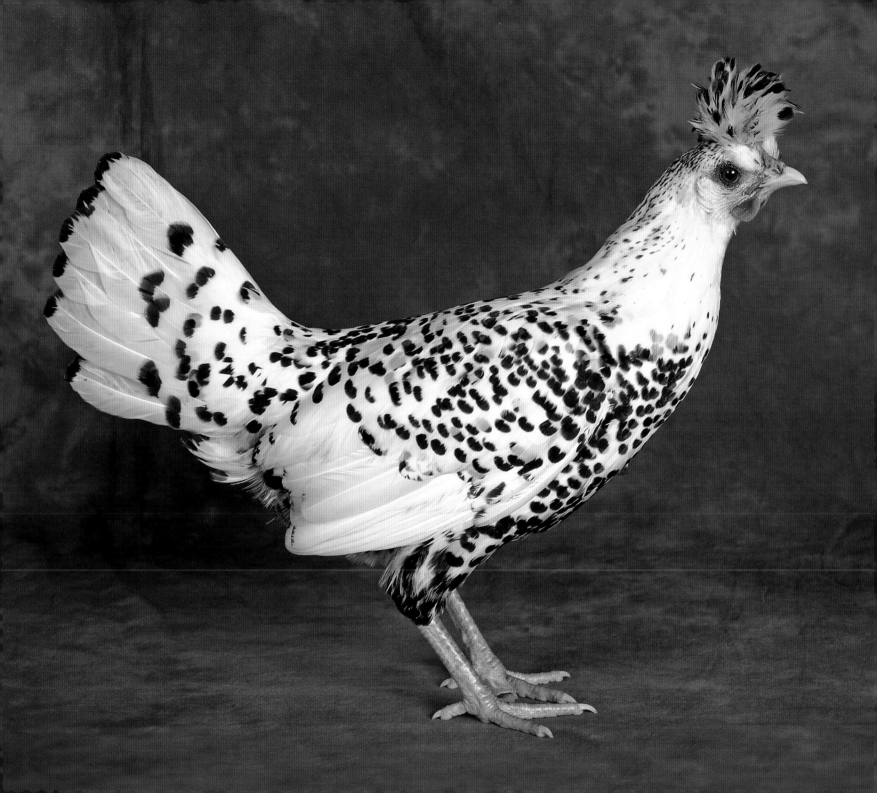

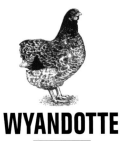

WYANDOTTE

HEN

I t is easy to spot the WYANDOTTE, with its unmistakably round shape. A docile, but friendly bird, this breed is particularly popular throughout Europe and the USA. The Wyandotte's profuse, puffy feathers give it a soft, downy look.

Features

This attractive breed sports a small rose comb with bright red points. It has yellow legs and red wattles, ear lobes and eyes. Its small head and thick, feathered neck top a rotund, heavy body with a short back and a round, sweeping tail that forms an inverted 'V' shape. Wyandottes are bred for both standard and bantam sizes, and come in many feather colours and patterns including white, black, blue laced, blue, buff, red, barred, golden and blue laced red (shown here).

Use

The Wyandotte breed is a steady layer of large brown eggs and the hens often prove decent brooders. Though their fluffy plumage makes them appear more substantial than they really are once the feathers come off, they are often raised for meat, and make a fine dual-purpose bird. The Wyandotte's rose comb withstands frigid temperatures, making it a hardy, cold-tolerant breed.

Related Breeds

The Wyandotte's related fowl include the Sebright Bantam, Brahma, Spangled Hamburg and Yellow Chittagong breeds.

Size

Hen weight 3 kg (6½ lb)

Cock weight 3.9 kg (8½ lb)

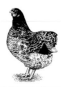

Origin & Distribution

The Wyandotte was the first breed ever developed in the USA. It was named after the Wendat, a Native American tribe indigenous to the north-eastern states where Wyandottes were developed. Today the breed is found in Europe, North America and Australia.

USA

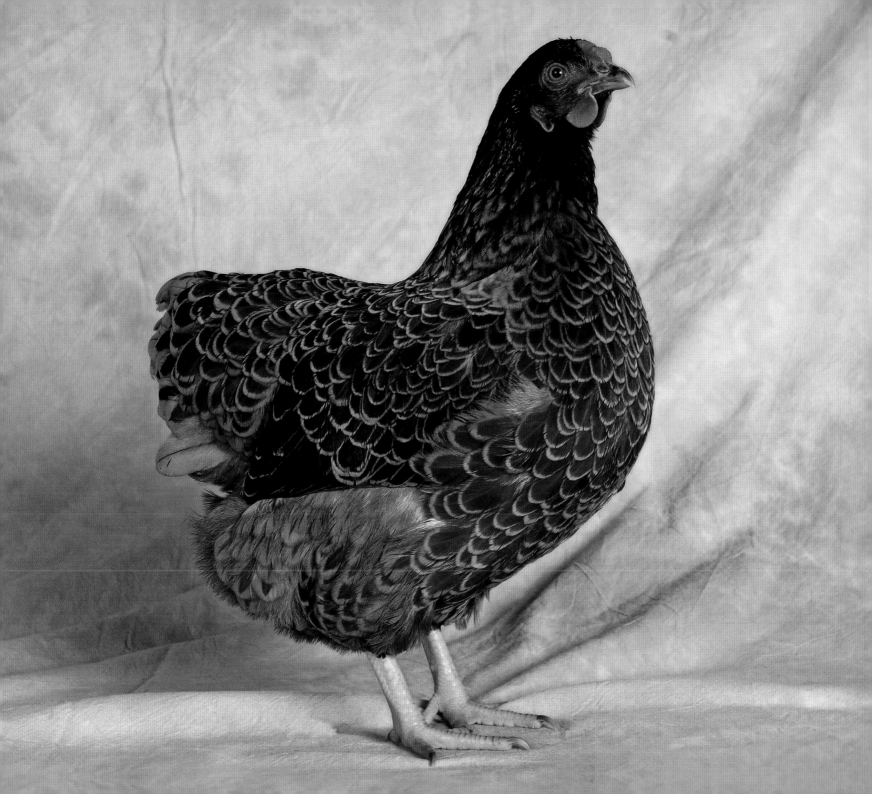

FRIZZLE

HEN

The Frizzle looks as if it has just stepped out of a beauty parlour; its distinctive feathers curl upwards, lending it a coiffed appearance. The frizzled feather type stems from a gene mutation inherited by only half the offspring when Frizzles are mated. Breeders maintain some smooth types in the breeding pool, because repeated pairings between frizzled birds can produce birds with brittle, narrow feathers.

Features

Its fluffy plumage distinguishes this breed from the rest. The Frizzle's characteristic rounded shape results from its curved breast, erect tail feathers and broad body that sits atop rather stubby, featherless shanks. The Frizzle beak and legs are yellow, whilst wattles, ear lobes and comb appear a fiery red colour. The single comb stands upright and is of medium size.

Use

Prized for their showy looks, Frizzles are bred mostly for their ornamental value. However, they are also a popular choice for garden hobbyists, as the hens provide a reliable supply of tinted eggs and are good setters, known for their broodiness.

Related Breeds

Though known as a separate breed in Great Britain, the Frizzle mutation can appear in most established breeds, giving it the Frizzle's distinctive feather shape. Cochins, Japanese Bantams and Polands are breeds that often display the frizzle feather type.

Size

Hen weight 2.7 kg (6 lb)

Cock weight 3.6 kg (8 lb)

Origin & Distribution

The Frizzle's origins remain unclear, partly because the mutation may have arisen in multiple regions and breeds simultaneously. It is thought to hail from Asia; sightings were reported there as early as the 1700s. Today the breed is kept all over the world.

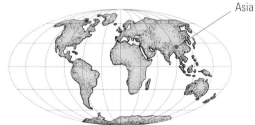

Asia

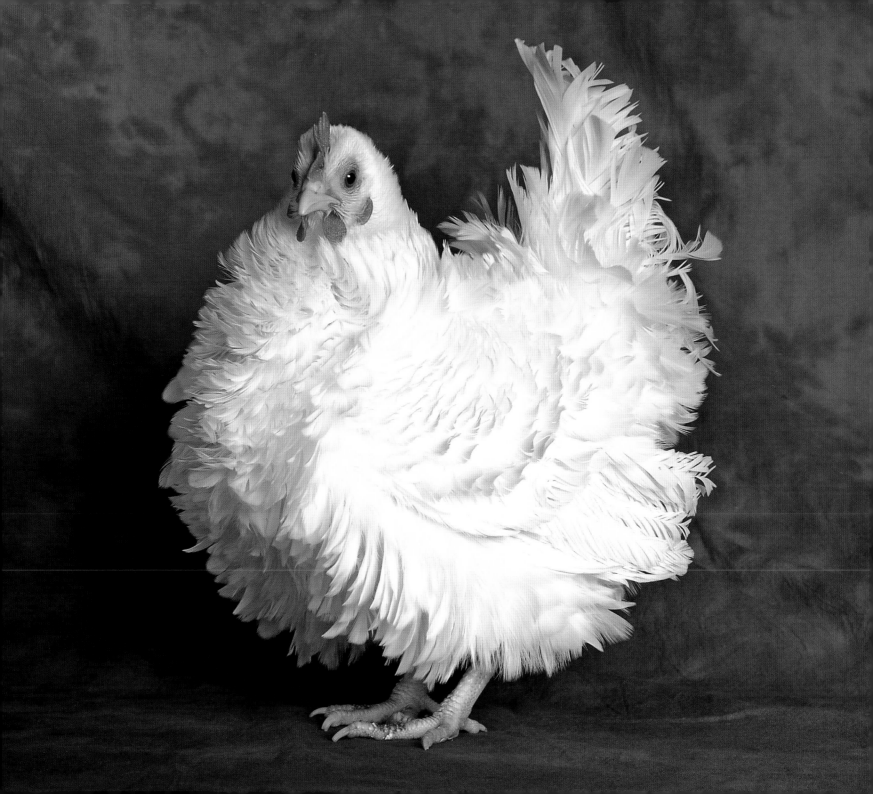

FAVEROLLES

HEN

Named after the northern French village of Faverolles, the exact pedigree of the FAVEROLLES remains unclear, but legend has it that it was bred for meat production and winter laying. These bantam-sized birds are personable, good-natured fowl that do not fly much and do well in small pens, although they easily become fat if not given enough opportunity for regular exercise.

Features

Faverolles have a thick, robust body shape. The back is long and the tail is well-feathered. The male comb stands erect with four to six peaks and the female's comb is similar but smaller. A feather muff wraps around the face and partially conceals the small ear lobes and wattles. They can exhibit a variety of colour schemes including black, blue-laced, buff, cuckoo (shown here), ermine, salmon and white.

Use

The Faverolles is a dual-purpose fowl, often raised for meat, but also kept for its reliable production of light brown eggs, which are decent-sized, even in the bantams like this one. Faverolles bantams mature fairly rapidly and are not particularly aggressive.

Related Breeds

The Faverolles probably got its white flesh from the Houdan and Dorking, and the breed is also related to the Cochin and Brahma.

Size

Bantam hen weight 0.9–1.1 kg (2–2½ lb)

Bantam cock weight 1.1–1.4 kg (2½–3 lb)

Origin & Distribution

Developed in France in the mid-1800s, the Faverolles were brought to Britain in about 1895 and around the same time also became well established in the USA, where it was admitted into the American Poultry Association's *Standards of Perfection* in 1914. Today Faverolles are kept by fanciers the world over.

France

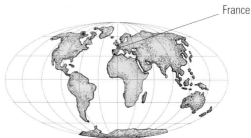

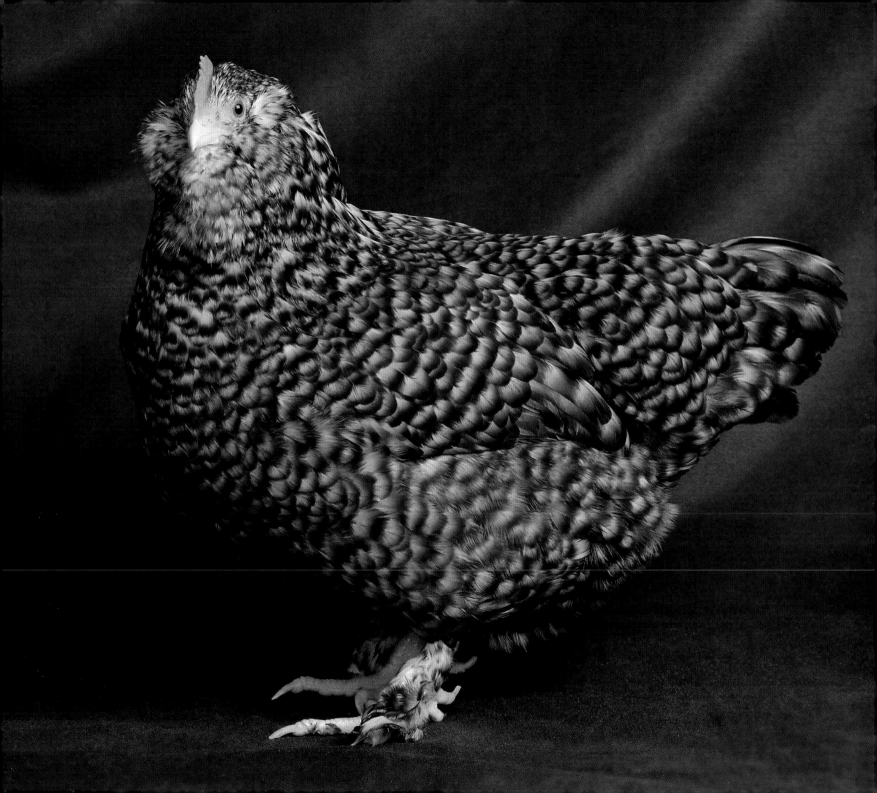

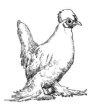

BURMESE

HEN

A true bantam with no full-size equivalent, the BURMESE has never been especially popular. Its crested head, and short, ornately feathered legs give it an unmistakable appearance. In his 1900 book, *The Variation of Animals and Plants Under Domestication*, Charles Darwin classified Burmese bantams as 'creepers or jumpers' and described an 'almost monstrous shortness of legs so that they move by jumping, rather than walking'.

Features

The Burmese bantam's most characteristic trait is its miniscule legs, so short that the bird appears to be sitting down, even whilst standing upright. It has a soft, crested head, a horn comb and curt wattles. The body is deep and rounded and it carries its wings low. Ornate feathers cover the compact legs in a pretty fan.

Use

Their small size makes Burmese bantams well suited to small spaces, but they require extra care. Due to their extremely short legs, they must have dry bedding at all times and do not tolerate wet weather very well. Hens lay brown eggs surprisingly large for the bird's size, but they are not especially fertile.

Related Breeds

Once virtually extinct from most of Europe and Britain, the breed was revived via careful breeding with Japanese Bantam, Cochin, Crevecoeur and Belgian Bearded d'Uccle bantams.

Size

Bantam hen weight 500 g (18 oz)

Bantam cock weight 600 g (21 oz)

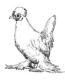

Origin & Distribution

Burmese bantams originated in the country known today as Myanmar (formerly Burma). They arrived in England during the 1880s when British sailors brought them home from their travels. The breed virtually disappeared from Europe in the early 20th century, but thoughtful breeding saved them from extinction.

Myanmar

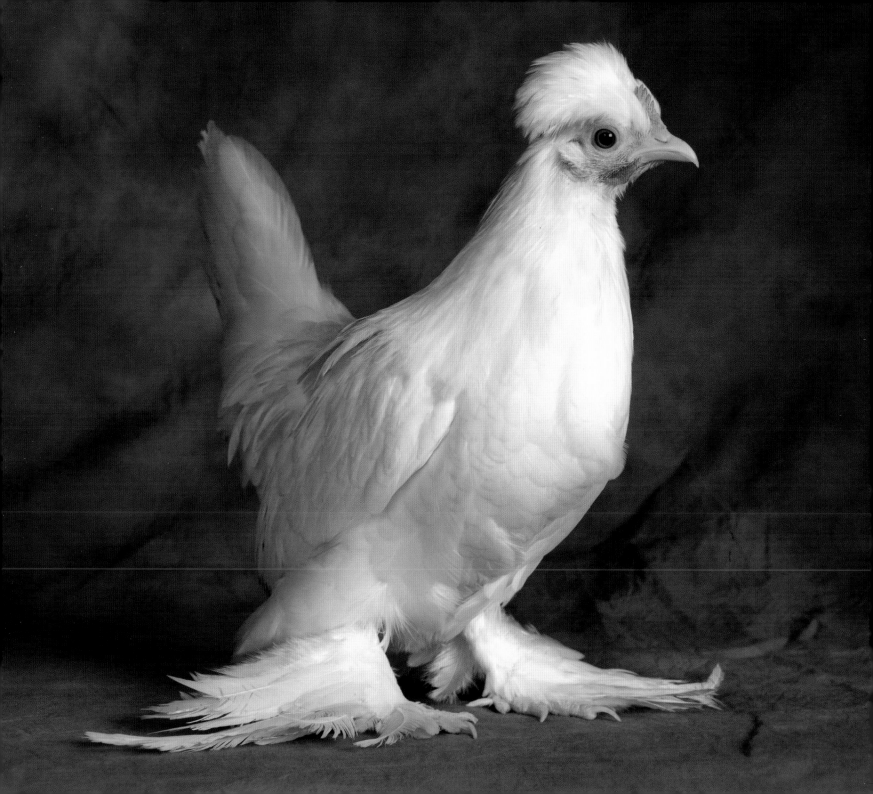

EGYPTIAN FAYOUMI

COCK

Alert and even flighty, the EGYPTIAN FAYOUMI has a bit of a feral streak. They are capable, strong fliers, and if left to their own devices may do quite well foraging on their own in favourable environments. Although not an especially common breed, they are attractive and easy to keep.

Features

Their upright carriage and wedge shape gives the Fayoumi a game-like appearance. The bird's necks are long and thin and their bodies are rounded. A long back extends to a similarly long tail, which in males, like the one pictured here, is often well spread and framed by a flowing saddle. Ear lobes and wattles are a bright red hue, as is the single comb, which is generally upright with even serrations. The breed comes in two colour types: gold pencilled and silver pencilled (shown here).

Use

A hardy, strong breed, Fayoumis are attractive enough for show, but were developed especially for egg production. They mature quickly – hens may begin to lay as early as four or five months. Eggs are white or cream-coloured.

Related Breeds

The Egyptian Fayoumi's development remains a bit of a mystery, but they share similarities in appearance to the Campine.

Size

Hen weight 1.4–1.6 kg (3–3½ lb)

Cock weight 1.8 kg (4 lb)

Origin & Distribution

Named after the Fayoum district of Egypt where it originated many generations ago, this ancient breed is a relative newcomer to the UK, arriving only in 1984. It is also found in North America, but it remains uncommon there. This breed is also kept by fanciers in other parts of Europe.

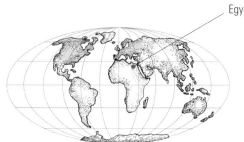

Egypt

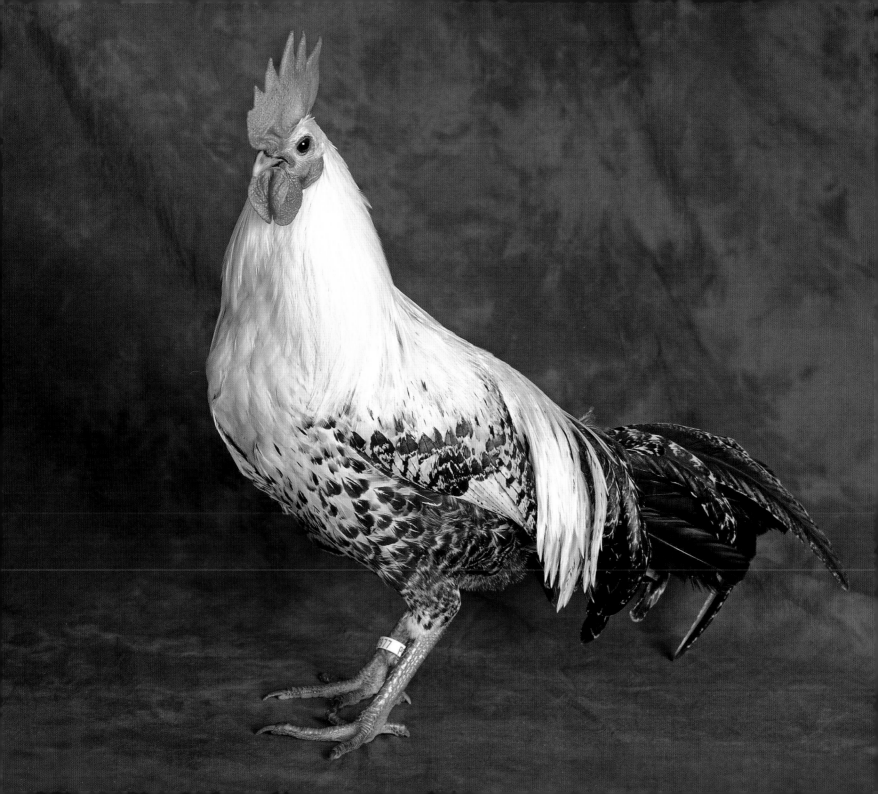

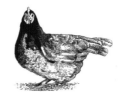

SCOTS DUMPY

HEN

The Scots Dumpy's unique stunted body makes it easy to distinguish. Variously known as Creepers, Bakies and Crawlers, the Scots Dumpy is one of Scotland's oldest breeds and was first shown in London in the mid-1800s. These birds are simpler to round up than most, as their short legs make them especially easy to catch.

Features

The Scots Dumpy's hallmark features are its extremely short legs and its big, heavy body that sits low to the ground. Owing to its stumpy legs and low body, it moves with more of a waddle than a walk, and it has a long body and broad, flat back. The tail features flowing feathers and extended sickles. The small head is adorned with a medium-sized single comb with uniform serrations. Ear lobes and wattles are moderately sized.

Use

Considered a dual-purpose breed, the Scots Dumpy has white skin and ample meat. Hens produce a consistent number of eggs, which may be white or dark. They are often used as sitters, since they are quite broody and make superior mothers. They are active and able foragers, but may become destructive when kept under close confinement.

Related Breeds

The Scots Dumpy's exact origins remain a bit murky. They are related to the Scots Grey and possibly to Dorkings and their related breeds, as they once commonly possessed a fifth toe. The Malay may have also played a role in this bird's development.

Size

Hen weight 2.7 kg (6 lb)

Cock weight 3.2 kg (7 lb)

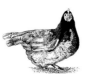

Origin & Distribution

The Scots Dumpy originated in Scotland, where it has been kept for at least a century. It has ancient origins – poultry with typical dumpy characteristics were described as far back as AD 900. Today the breed is found in North America as well as Europe.

Scotland

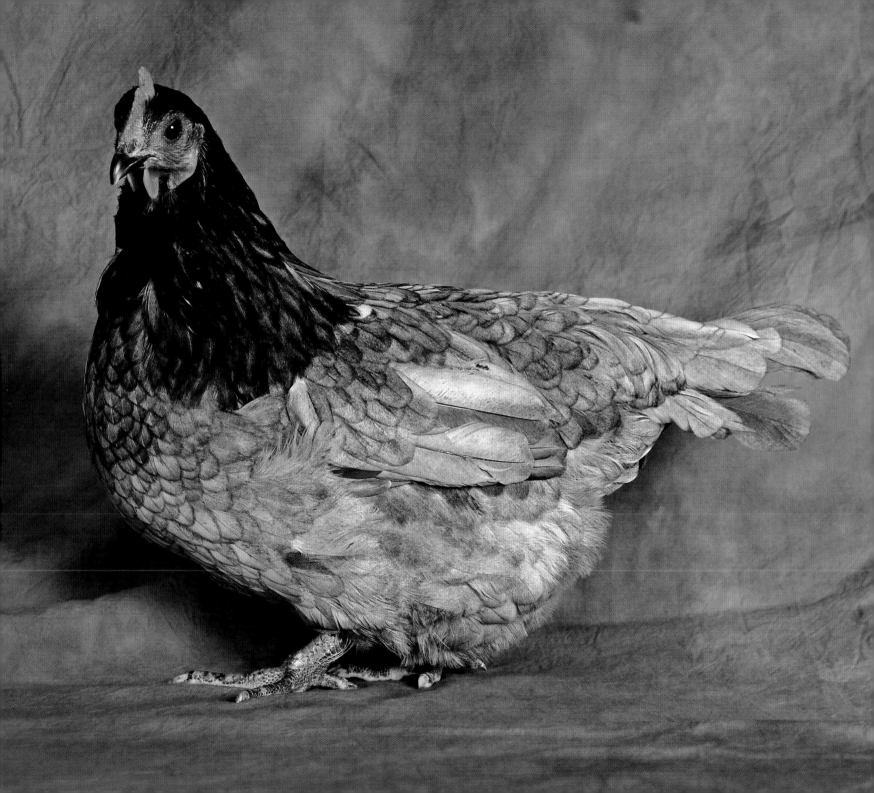

DORKING
HEN

Ⓞne of the oldest English breeds, the Dorking probably originated in the time of the Roman Empire. They are striking birds, notable for their large and distinctive round shape. Due to their size, hens may require extra-large nest boxes to allow room to lay without injury. The breed has a quiet demeanour and adaptable personality.

Features

The Dorking has a squat, massive body with a broad back and hearty saddle tilted down towards the full tail. It has red eyes, long, low-hanging wattles and an upright comb, although cuckoo and white colour types may have a rose comb. Hens have medium-sized combs, but the males' may be quite large. The breed has short, robust legs and a fifth toe. Dorkings come in five colour types: cuckoo, dark, red, white and silver grey (shown here).

Use

Prized for its ample size, Dorkings are kept mostly for their tasty white meat. Hens lay white eggs, which they readily brood over. The males' large combs make them susceptible to frostbite, but hens are winter hardy. The breed requires ample room to exercise or birds may plump with fat.

Related Breeds

Dorkings have been used to develop several new breeds including the Sussex and the Faverolles.

Size

Hen weight 3.6–4.5 kg (8–10 lb)

Cock weight 4.5–6.4 kg (10–14 lb)

Origin & Distribution

The *British Poultry Standards* calls the Dorking one of the oldest domesticated British breeds, but its ancestors remain a bit of a mystery. Chickens with the Dorking's unusual five toes were mentioned by the ancient Romans as early as AD 47, so this breed may have been developed with the help of Italian types. Today it is kept throughout Europe and North America.

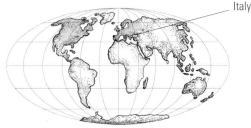

Italy

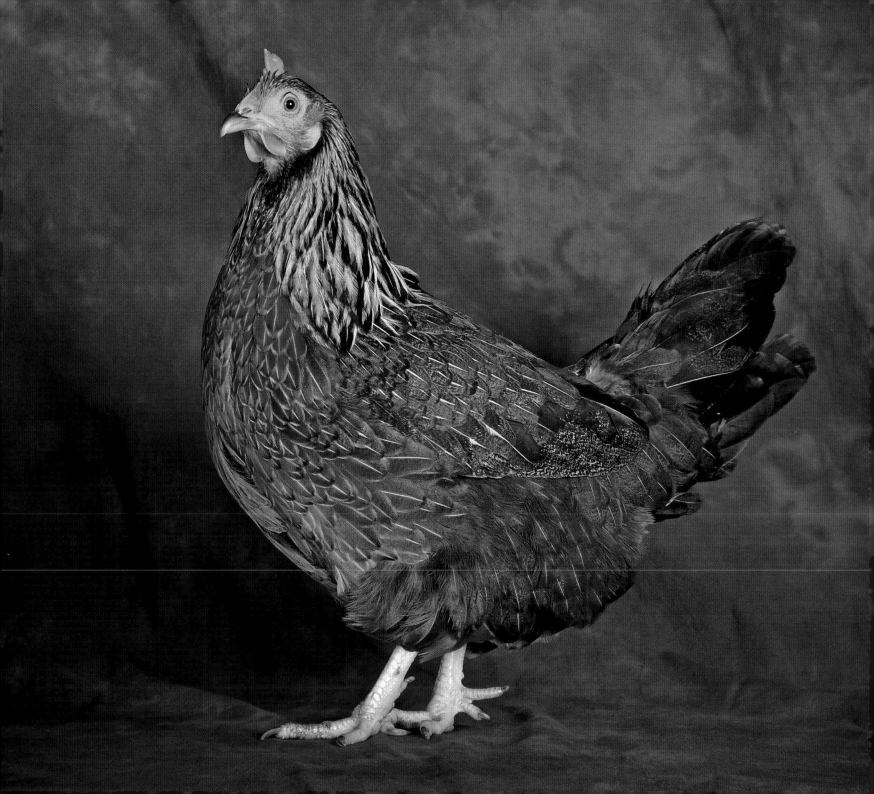

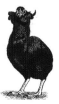

RUMPLESS TUFTED ARAUCANA

HEN

As its name implies, the RUMPLESS TUFTED ARAUCANA is related to the Araucana, but it is rarer and more difficult to breed. The gene associated with its hallmark ear tufts may be lethal in certain combinations, and a significant proportion of tufted chicks never make it out of the egg. The fowl lack tails and some vertebrae, and this unusual anatomy can hamper fertility.

Features

This breed's name encapsulates its most notable features: tufts of feathers on its ears and a stubby, tail-less rump. The body is round, with a full breast, broad shoulders and a sloping back. The breed has red eyes, a small pea comb, miniscule wattles and tiny ear lobes. Colour types include black-red, silver duckwing, blue, lavender, spangled, cuckoo, white and black (shown here).

Use

Like the Araucana, the Rumpless Tufted Araucana lays beautiful eggs, ranging from blue to green. Their attractive eggs make these hens popular for small-scale egg production. However, the breed's well-established fertility problems make them prized mostly amongst fanciers, rarely amongst commercial farmers.

Related Breeds

Closely related to the standard Araucana, the Rumpless Tufted Araucana was developed with the help of the Quetero and Collonca breeds of South America.

Size

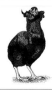

Hen weight 2.3 kg (5 lb)

Cock weight 2.7 kg (6 lb)

Origin & Distribution

Like the Araucana, the Rumpless Tufted Araucana originated in Chile from indigenous stock kept by native Chilean tribes. According to the British Poultry Club, a Professor S. Castello introduced the breed to Europe in the early 1920s. Today they are found throughout the world.

Chile

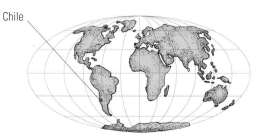

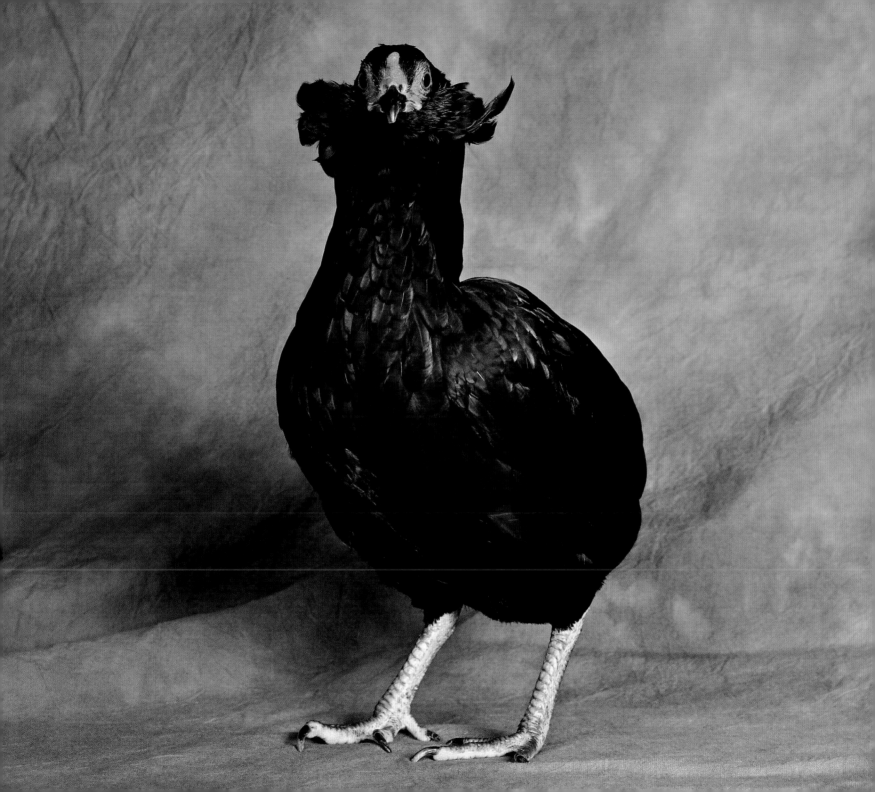

INDIAN GAME

HEN

Also known as the Cornish or Cornish Game, the INDIAN GAME is remarkably calm and tame compared to other game birds, though it can act aggressively on occasion. It is not a particularly active breed: the birds make poor grazers, preferring to wait by the feeder for the day's food. Their short, stubby legs and extra-large breasts can make natural mating difficult for some especially robust individuals.

Features

The Indian Game is most notable for its squat appearance, huge breasts and squarish body. Birds have narrow, hard feathers, a stubby tail and featherless legs that are short and thick. Males and females look remarkably alike, although the male's pea comb and wattles are significantly larger than those of the female.

Use

The Indian Game's abundant breast meat has made it a favourite breeding stock for commercial meat production, the bird being used to produce Cornish Rocks and other hybrids. Cold hardy, these fowl tolerate confinement. Hens are not especially prolific layers, but they often go broody and make good mothers.

Related Breeds

The Malay, red Asil, and the black-breasted red Old English Game Bantam were all used in the Indian Game's development and the Jubilee Indian Game is closely related to the Indian Game.

Size

Hen weight 2.7 kg (6 lb)

Cock weight 3.6 kg (8 lb)

Origin & Distribution

Developed in Cornwall, England, in the 1800s, the Indian Game was soon exported across the Atlantic. The breed is often known as Dark Cornish in the USA. Today the breed is used for commercial meat production around the world.

England

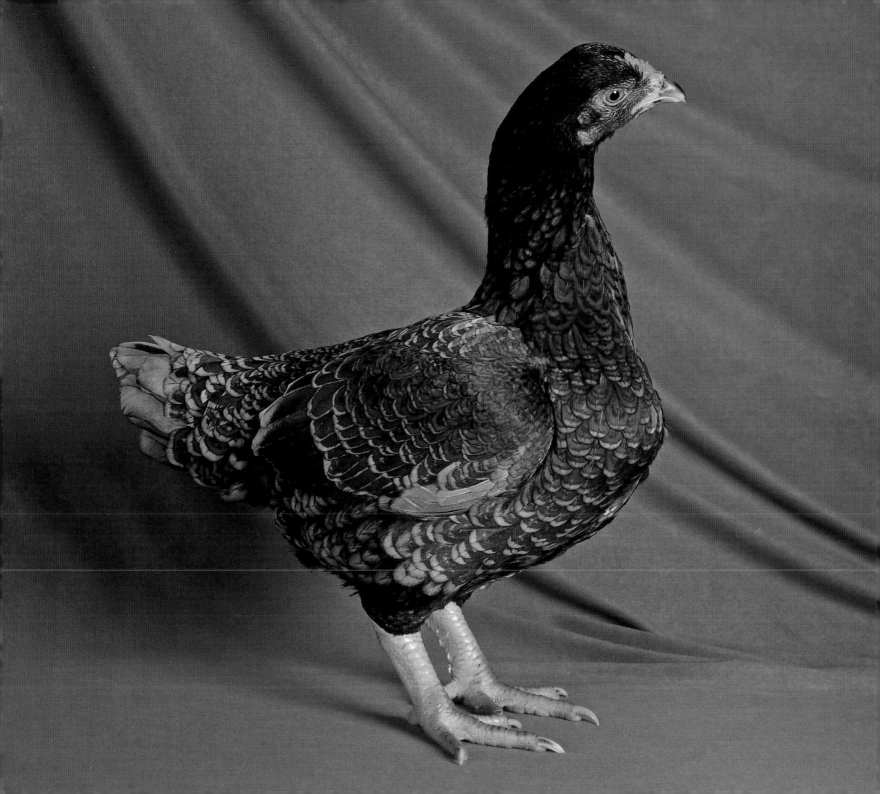

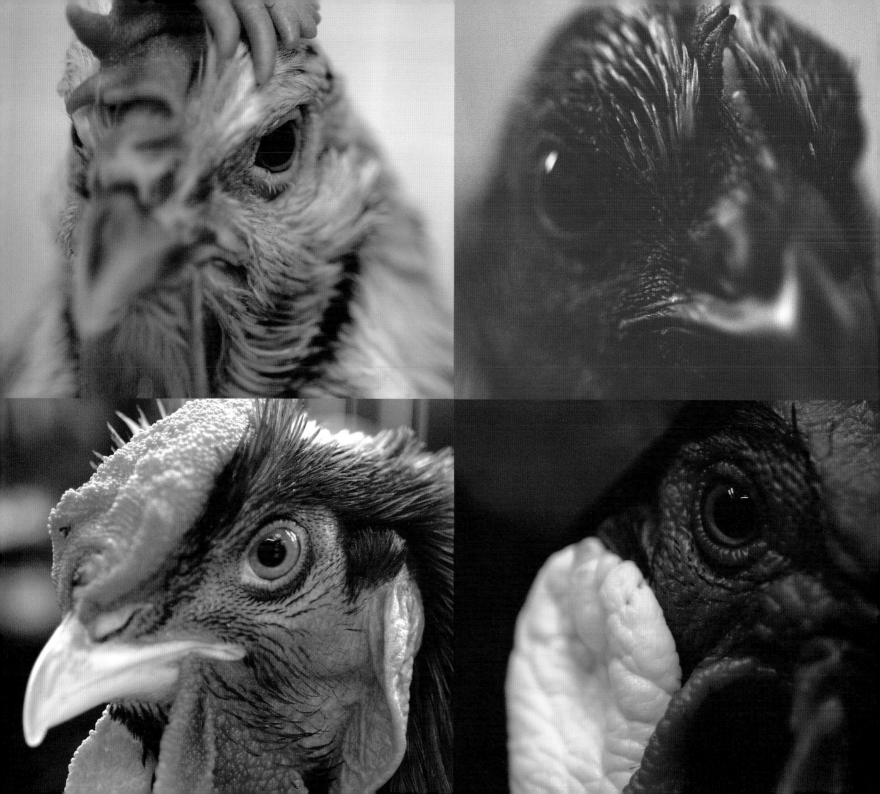

REPORTAGE

No dust baths here; matted feathers and muddy feet are left at the door. Behind the scenes a FINAL FLUFF-UP, a quick comb-through, and plenty of soothing words ensure that these queens (and kings) of the *poultry* world look their IMPRESSIVE BEST as they strut their stuff before an *awe-struck* public.

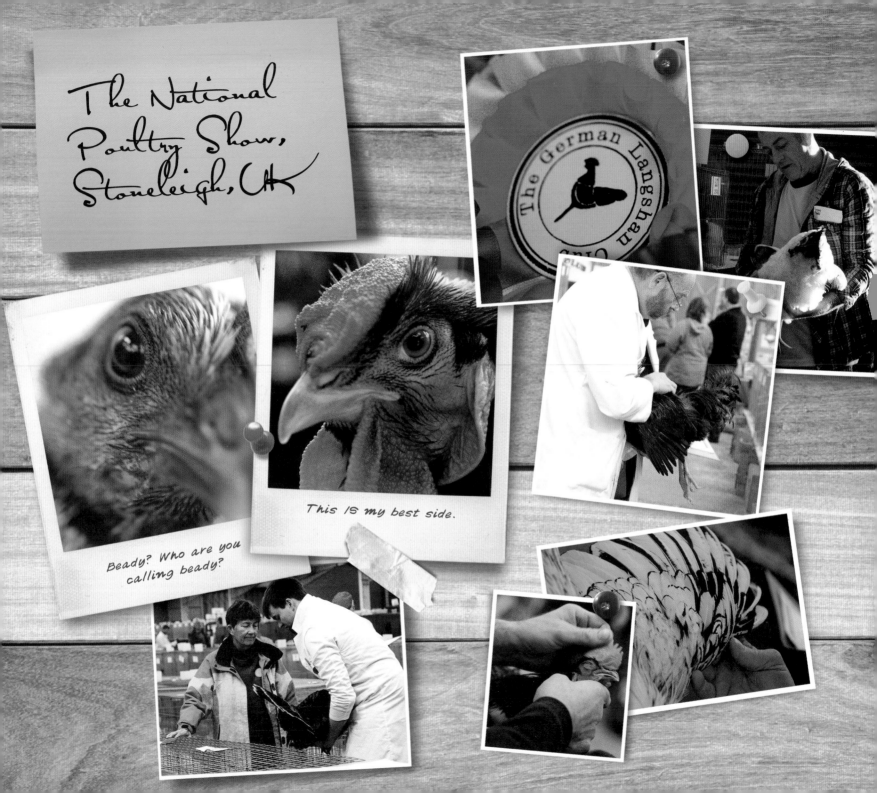

The National Poultry Show, Stoneleigh, UK

The German Langshan Club

This IS my best side.

Beady? Who are you calling beady?

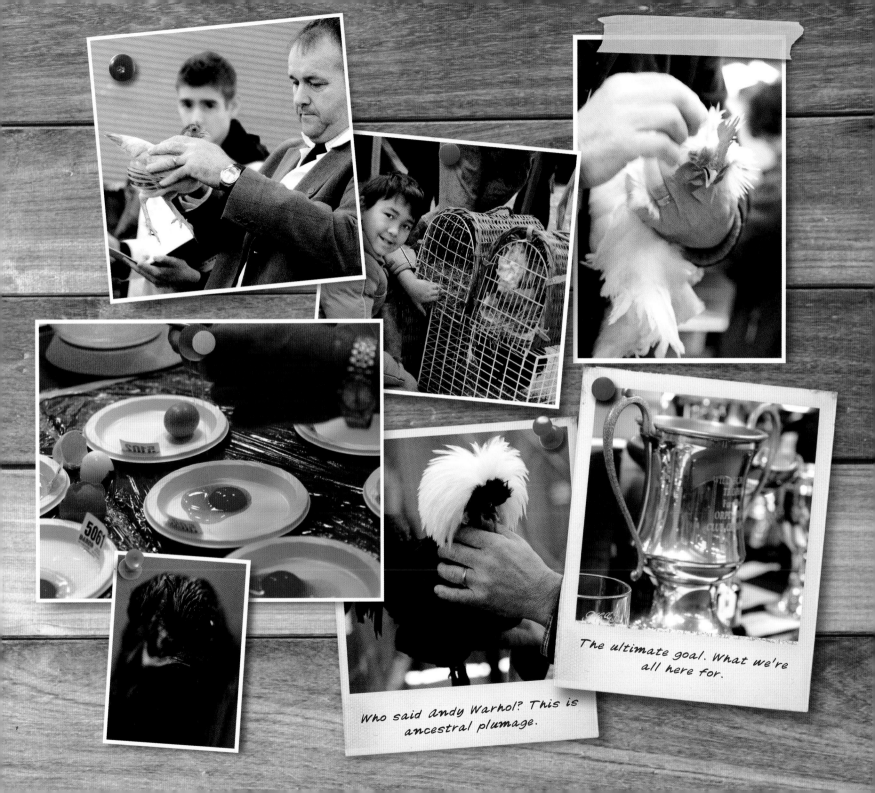

Who said Andy Warhol? This is ancestral plumage.

The ultimate goal. What we're all here for.

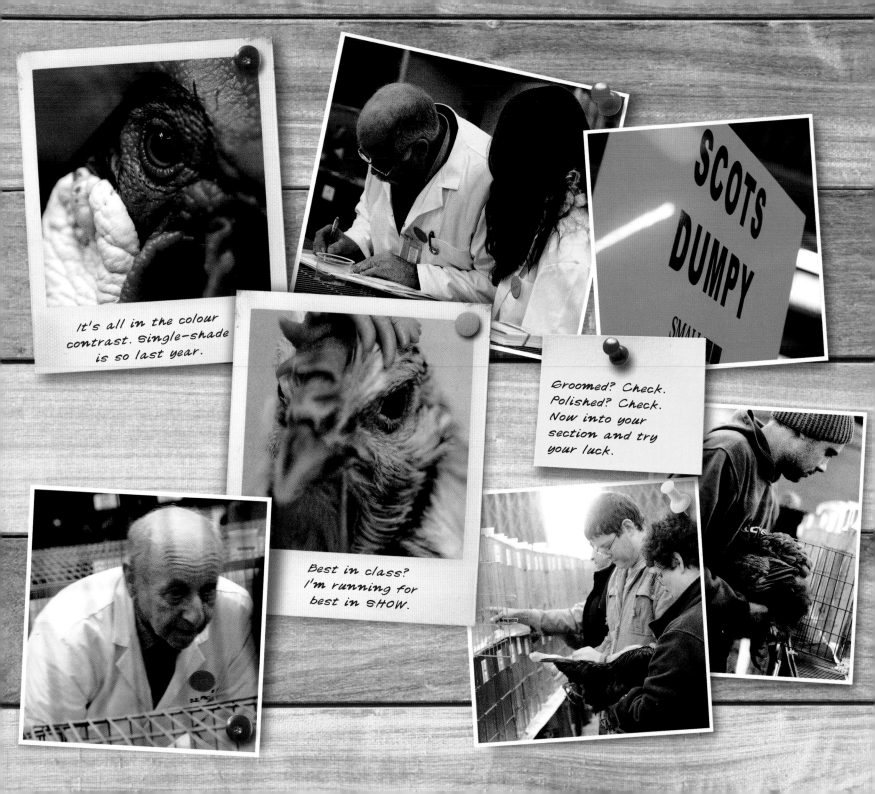

It's all in the colour contrast. Single-shade is so last year.

Groomed? Check. Polished? Check. Now into your section and try your luck.

Best in class? I'm running for best in SHOW.

SCOTS DUMPY

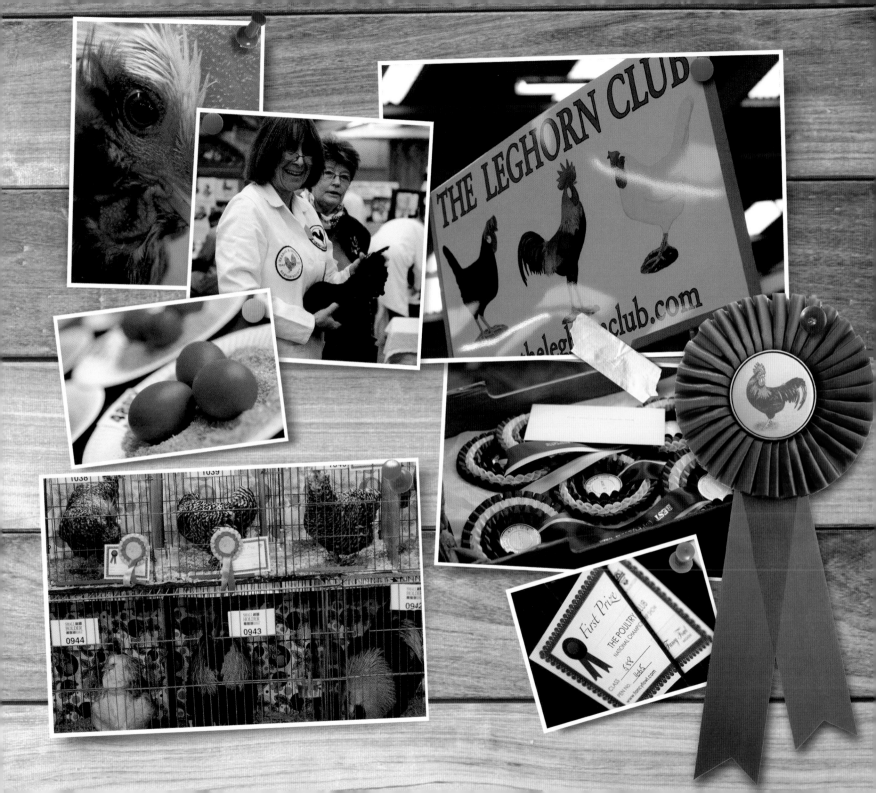

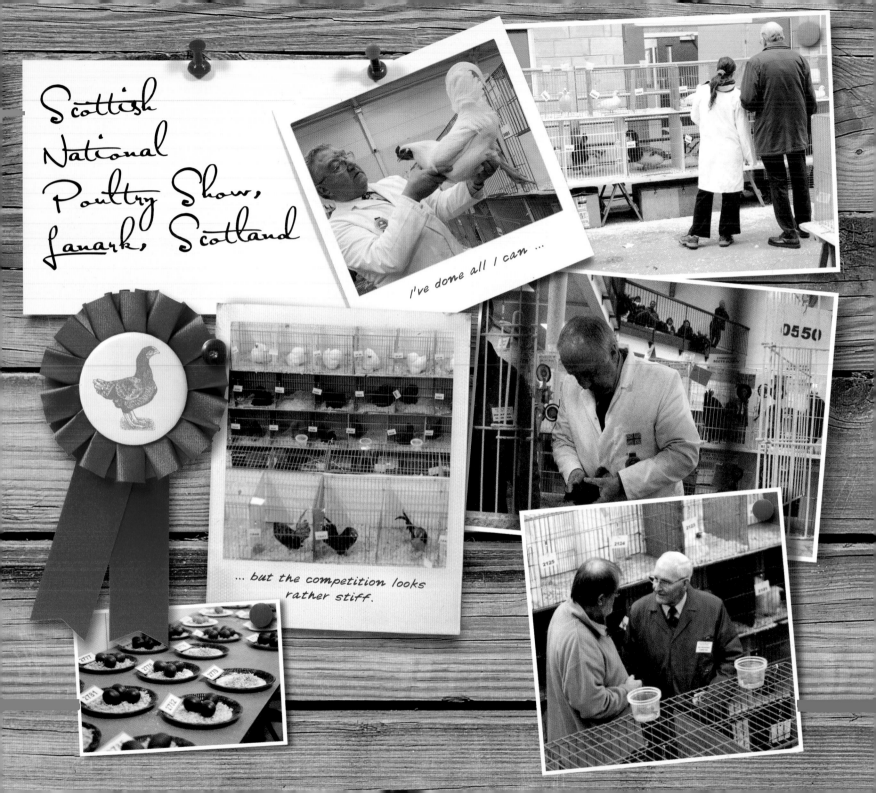

Scottish National Poultry Show, Lanark, Scotland

I've done all I can ...

... but the competition looks rather stiff.

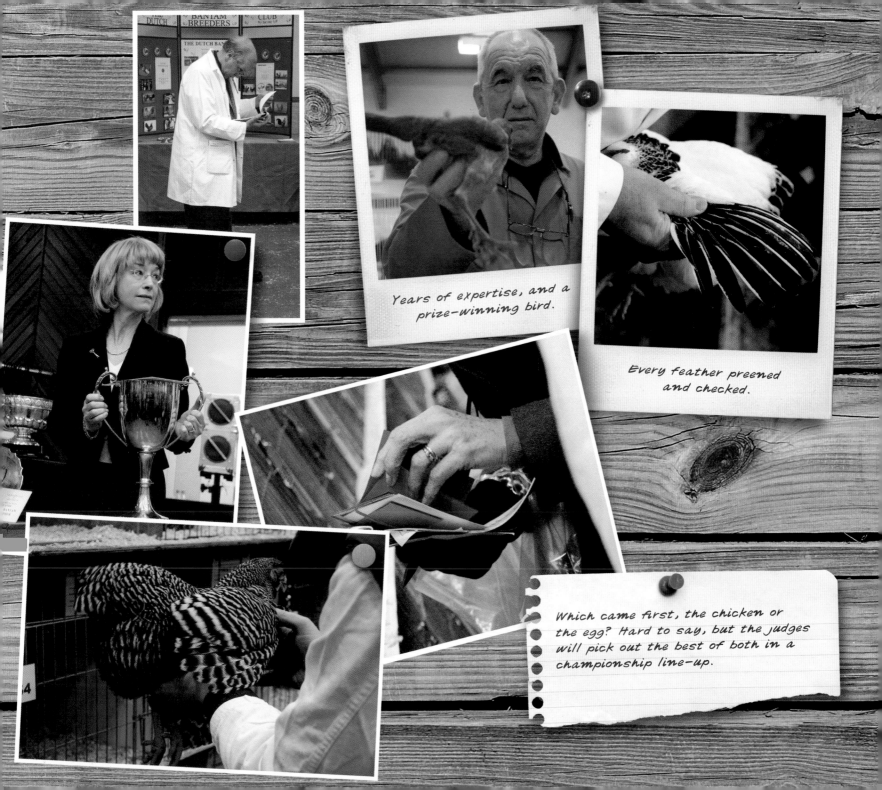

Years of expertise, and a prize-winning bird.

Every feather preened and checked.

Which came first, the chicken or the egg? Hard to say, but the judges will pick out the best of both in a championship line-up.

GLOSSARY

Bantam a small variety of chicken – either a miniaturised version of a standard breed, or a distinct breed that is substantially smaller than standard-sized breeds

Booted a description of breeds that have feathers on their shanks and feet

Broiler a chicken butchered while young to produce tender meat

Broody a description of a hen that sits on her eggs to incubate them until they hatch

Chick a chicken that has just hatched

Class a grouping of fowl for competition purposes

Clutch a group of eggs that are incubated together to hatch at the same time

Cock a male aged one year or older

Cockerel a young male that is less than one year old

Comb the fleshy protrusion on the top of a chicken's head

Crest the billowy feather hat atop certain breeds such as the Silkie and Polish

Cushion comb a type of small comb that sits close to the head

Dual-purpose breed a breed suitable for both egg and meat production

Dub to trim the comb short

Fancier one who keeps chickens for pleasure, rather than solely for profit

Game bird a breed descended from stock used for cockfighting

Hackles plumage on a chicken's neck, especially the rear and sides of the neck

Hard feather a type of coarse, tough feather often found on game birds

Hatch rate the proportion of a clutch that hatches

Hen a fully mature female chicken

Layers hens kept for their eggs

Nest box a confined area where a hen can lay her eggs in private

Pea comb a type of low-lying comb with three distinct ridges that come together at the base, as seen in the Brahma

Pin feathers developing feathers, the tips of which are just emerging

Plumage a bird's feathers

Primary feathers coarse, stiff feathers at the far tips of the wings

Pullet a female that is less than one year old

Roost a branch, board or bar where chickens perch at night

Rose comb a type of broad comb that is covered with tiny points and forms a spike at the far end

Saddle the rear section of a chicken's back just before the tail

Secondary feathers a chicken's quill feathers on the wings

Shank the portion of a chicken's leg from the joint to claw

Sickles the curved top feathers on a male's tail

Spurs sharp, claw-like protrusions on a rooster's shanks

Tuft a fluff of feathers somewhere on a chicken's head

Vent orifice through which eggs and droppings emerge (via distinct pathways)

Walnut comb also known as a 'strawberry comb', this comb lies close to the head and resembles the outer portion of a strawberry that has been cut in half

Wattles the fleshy jowls that protrude from the base of a chicken's beak – they are usually larger and more pronounced in males than in females

SHOWS

CHAMPIONSHIP SHOWS

The following is a list of shows designated 'Championship' by the Poultry Club of Great Britain, reassessed on an annual basis.

January:	Selston, The Scottish National, The Northern Poultry Show, Pool Poultry Club, High Peak, Ballymena
February:	Belper Poultry Society, Ulster Federation, North of England, Devon Fanciers, Peebles and District, Reading
June:	Three Counties, North Yorkshire County
July:	Great Yorkshire
August:	Pembrokeshire Agricultural
October:	Ribble Valley, Hants & Berks, Oswestry
November:	Holme and District, Dyfed, Kent Poultry Fanciers, Egremont, Welsh Federation, Welsh Winter Fair
December:	Welsh Winter fair

THE NATIONAL CHAMPIONSHIP SHOW
Website: http://www.poultryclub.org/National.htm

USA
AMERICAN POULTRY ASSOCIATION
Website: http://www.amerpoultryassn.com

OHIO NATIONAL POULTRY SHOW
Website: http://www.ohionational.org

ASSOCIATIONS

THE POULTRY CLUB OF GREAT BRITAIN
Keeper's Cottage
40 Benvarden Road
Dervock
Ballymoney
Co. Antrim
BT53 6NN
Telephone: 02820 741056
Website: http://www.poultryclub.org

THE RARE POULTRY SOCIETY
Danby
The Causeway
Congresbury
Bristol
BS49 5DJ
Telephone: 01934 833619
Website: http://www.rarepoultrysociety.co.uk

USA
AMERICAN BANTAM ASSOCIATION
PO Box 127
Augusta, NJ 07822
Website: http://www.bantamclub.com

AMERICAN POULTRY ASSOCIATION
PO Box 306
Burgettstown PA 15021
Telephone: (724) 729-3459
Website: http://www.amerpoultryassn.com

THE AMERICAN LIVESTOCK BREEDS CONSERVANCY
PO Box 477
Pittsboro, North Carolina 27312 USA
Telephone: (919) 542-5704
Fax: 919-545-0022
Website: http://www.albc-usa.org

BREED ASSOCIATIONS

BRITISH BREED CLUBS
The Poultry Club of Great Britain
http://www.poultryclub.org/

The Araucana Club of Great Britain
http://www.araucana.org.uk/

The Australorp Club GB
http://www.poultryclub.org/australorpclubgb

BREED ASSOCIATIONS *continued*

The British Belgian Bantam Club
http://www.jatman.co.uk/belgians/

British Faverolles Society
http://www.faverolles.co.uk/

The British Poland Club
http://beebepolands.co.uk

The Cochin Club
http://www.cochinclub.co.uk/

The Dorking Club
http://www.poultryclub.org/dorkingclub/

The Frizzle Society of Great Britain
http://www.thefrizzlesocietyofgreatbritain.co.uk/

Japanese Bantam Club of Great Britain
http://web.ukonline.co.uk/japclub/

The Leghorn Club
http://www.theleghornclub.com/

Lincolnshire Buff Poultry Society
http://www.lincolnshirebuff.co.uk/

The Marans Club
http://www.themaransclub.co.uk/

The Minorca Club
http://www.poultryclub.org/minorcaclub/

Modern Game Club
http://www.moderngameclub.co.uk/

The Plymouth Rock Club
http://www.theplymouthrockclub.co.uk

Scots Dumpy Club
http://www.scotsdumpyclub.org.uk/

The Silkie Club of Great Britain
http://www.poultryclub.org/silkieclub/

UK Dutch Bantam Club
http://www.dutchbantamclub.org

The Welsummer Club
http://www.welsummerclub.org

NORTH AMERICAN BREED CLUBS
Ameraucana Breeders Club
http://www.ameraucana.org/

The American Silkie Bantam Club
http://www.americansilkiebantamclub.com/

American Sumatra Association
http://sumatraassociation.com/

The Araucana Club of America
http://www.araucana.net/

Bearded Belgian d'Anver Club of America
http://danverclub.webs.com/

Belgian d'Uccle & Booted Bantam Club
http://belgianduccle.hypermart.net/

Canadian Araucana Society
http://members.shaw.ca/
CanadianAraucanaSociety/

Canadian Plymouth Rock Club
http://www.members.tripod.
com/~clubhomepages/Plymouth_Rock.html

Faverolles Fanciers of America
http://www.faverollesfanciers.org/

Modern Game Bantam Club of America
http://www.mgbca.org/

National Frizzle Club of America
http://web.archive.org/web/20030602183800/
www.webcom.com/777/nfcoa.html

North American Hamburg Society
http://www.northamericanhamburgs.com/

Plymouth Rock Fanciers Club of America
http://www.showbirdbid.com/joomla/rockclub/

Polish Breeders Club
http://www.polishbreedersclub.com/

Rhode Island Red Club of America
http://www.crohio.com/reds/

AUSTRALIAN BREED CLUBS
Australorp Club of Australia
http://www.australorps.com/

Silkie Club of Australia Inc.
http://www.freewebs.com/silkieclubofaustralia/

REFERENCES

The American Standard of Perfection (1905), American Poultry Association

British Poultry Standards, Victoria Roberts and the Poultry Club of Great Britain

The Complete Encyclopedia of Chickens, Esther Verhoef and Aad Rijs

The Field Guide to Chickens, Pam Percy

The Poultry Club of Great Britain website, http://www.poultryclub.org

Storey's Illustrated Guide to Poultry Breeds, Carol Ekarius

AUTHOR'S ACKNOWLEDGEMENTS

To the Little Red Bastard, the rooster we will never forget.

This book would not exist without the help of Carol Ekarius, who offered information, support and friendship. Her book, *Storey's Illustrated Guide to Poultry Breeds*, was an invaluable resource.

My thanks to Polita Anderson and Tom Kitch at Ivy Press for their skilled and cheerful editing.

PUBLISHER'S ACKNOWLEDGEMENTS

We would like to thank the organisations below for their help and cooperation in arranging the photo shoots at the agricultural shows.

Special thanks to Chris Parker, Ann Bachmet, Toddy Hamilton-Gould and Robert MacDonald.

The National Poultry Show
www.poultryclub.org

The Scottish National Poultry Show
www.scottishwaterfowlclub.co.uk

We would also like to thank all the chicken owners and breeders for their time and assistance at the photo shoots:

Belgium Barbu D'Anvers Derrick Elvey
Orpington Richard O'Rourke
Rhode Island Red J. Benson
German Langshan Dilwyn Green

ACKNOWLEDGEMENTS *continued*

Croad Langshan Clare Curtis
Dutch Bantam David Taylor
Rosecomb Bantam Catherine Slater
Yokohama Tinson & Hidden
Plymouth Rock Richard Everatt
Sumatra Tinson & Hidden
New Hampshire Red Mr William Blyth
Welsummer Beverley Downe
Barnevelder Mr F.C. Millward
Hamburgh J.D. Owen
Nankin Miss P.M .Fieldhouse
Old English Game Bantam Mr S. Owen
Leghorn James Crowther
Araucana Mrs J.A. Lawrence
Minorca John Harrop
Japanese Bantam Mrs A. Elvey
Maran Mr William Blyth
Cochin Dorinda Fontana
Sussex O. Chalker & Son
Booted Bantam Dorinda Fontana
Brahma Mr R.J. Bett
Poland Beverley Chilvers
Ko Shamo Tyler Baker
Sebright Bantam J. Kestell
Modern Game P.T. Watkinson
Silkie Linda Law
Malay Martin Stephenson
Ancona Aeron Wyn Williams
Australorp Mr C. Mitchell
Appenzeller Spitzhauben Rose Zdrojewski
Wyandotte Jordan Day
Frizzle Simon Gambling
Faverolles William & Karen Pimlott
Burmese Andrew Sheppy
Egyptian Fayoumi Lana Gazder
Scotts Dumpy Toddy Hamilton-Gould
Dorking Sue Woods
Rumpless Tuffted Araucanna SMC Thurland
Indian Game Mrs Davy

111

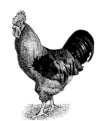

INDEX